impressionism

impressionism

Text by
Joseph-Emile MULLER

LEON AMIEL PUBLISHER
NEW YORK

Published by
LEON AMIEL PUBLISHER
NEW YORK, 1974
© 1974 SPADEM
Printed in France

Nothing seems easier at first sight than defining Impressionism. Since the movement is well-known, it would seem to be enough to name the painters who were associated with it and to define the characteristics of their works. But when one pays close attention to the distinctive traits of each painter, one quickly realizes that in certain areas there are many more contrasts than similarities.

Some impressionist painters, for example, can be defined as working in an orthodox manner (especially Monet, Pissarro, Sisley). There are others for whom Impressionism served only as a stimulus, a friendly environment, a shortlived temptation, a stage in their development or a starting point. It is important, when all of these artists are brought together under the title of Impressionism, not to lose sight of these differences. Of course it would be wrong to try to deprive the movement of its real significance, but at the same time the personal contribution of the main artists related to it must be emphasized. The more one studies their pictures, the more one realizes that they are each the unique expression of powerful and original personalities.

This observation is the guiding idea of this book. Obviously there is not enough space here to consider all the painters who may have been linked in one way or another with Impressionism. The criterion for selection has always been the importance and scope of the paintings, regardless of whether the artists were highly representative of the tendency, were simply close to it, influenced by it, or whether they borrowed some elements from it. This book intends to show that the impressionist period is a great one that not only inaugurated a new art but enriched us with a long and splendid series of masterworks.

Édouard Manet

" M. Manet... neither claimed to throw over old forms of painting, nor to create new ones. He simply sought to be himself and no one else." If Manet (1832-1883) thought it necessary to write this in the catalogue of his exhibition of 1867, it was undoubtedly less to reveal his true intentions than to camouflage them before the eyes of a hostile public. He, whose *Déjeuner sur l'Herbe* had been inspired by Raphael and Giorgione, who had painted his *Olympia* inspired by Titian's *Venus of Urbino*, could not fail to realise the novelty of his paintings since they immediately invited one to measure the distance which separated them from their models.

When Giorgione had in his *Pastoral Concert* shown two females naked alongside two dressed men, these nudes were idealised, their faces anonymous and overshadowed, the light which surrounded the figures had the poetry of melancholy twilight, the whole scene took on a legendary aspect. There is nothing of this in Manet. These two men in the *Déjeuner sur l'Herbe,* you might have met them, wearing the same clothes, on the boulevards of Paris. Far from any idealisation, the body of this naked woman is as individualised as her face. As for the light,

it is cold and ordinary. The whole picture possesses a realistic note which contradicts the absurd situation in which the figures are shown.

The same applies to *Olympia.* A critic wrote, " M. Manet who paints sullied virgins will not be accused of idealising foolish virgins." What was the meaning, beside that sickly anaemic, "cadaverous" nude, of the presence of the negress and that black cat which, wrote Théophile Gautier, "leaves the imprint of its muddy paws on the bed?" The truth is that in these two works the subject is nothing more than a pretext; the essential is not the relationship which might exist between the principal figures, it is that which exists between the colours, between the forms. When Manet wanted to add a light patch, he painted a nude; when he wanted to contrast this light patch with a dark note, he painted a man in a black jacket, a negress, a cat. In other words painting, which up to then had been nothing but a means, becomes an end in itself. This was an innovation too upsetting to ingrained attitudes not to appear a provocation, a challenge thrown at the public.

The style of *Olympia* was disconcerting too. These flattened volumes, these wiry outlines, these shadows which, adds Théophile Gautier, "are indicated by streaks of

boot polish of varying width," these vast light areas that collide with dark ones without any intermediate transitional stage, this reduction of depth that brings out the figures with precision, like close-ups on a screen; all this is contrary to painting as it had been practised in Europe ever since the 15th century, all this heralds the painting of the future.

However, although under the influence of Japanese prints, which Paris had just discovered with enthusiasm, in *Olympia,* the *Fifer,* the *Portrait of Théodore Duret,* Manet had moved away from tradition, in other pictures he remained attached to it and limited himself to sepaking its language with personal inflections.

In 1874, Berthe Morisot, who had become his sister-in-law, drew him closer to the Impressionists. That is to say, Manet altered his palette, making use of brighter, more luminous colours, but he very rarely got down to painting a pure landscape. Although he was ready to observe the play of light, atmospheric effects on the Seine or on the Grand Canal in Venice, he refused to sacrifice tangible elements; he continued to value the presence of human forms, their firmness and their balance.

Without any doubt, he remained faithful to the human image also because he enjoyed watching the society of his period. There was in him something of the loiterer and the recorder. The elegant, strolling crowd attracted by the music in the Tuileries or a masked ball at the Opéra, road-menders

in the rue de Berne, these were some of his subjects. He looked at them with detachment rather as if they were objects in front of a camera. Yet his art goes beyond a cold objectivity; although Manet was not passionately involved when he was looking, he was when he was painting. Alert, carried away, at the same time very free and very evocative, his touch resembles that of Franz Hals and Velasquez, both of whom he particularly admired.

As for colouring, it appears to have nothing far-fetched, yet it is distinguished. His somewhat acid freshness at times becomes frigid, but the effect is rich and heady. When Manet adopted the palette of the Impressionists he did not, however, give up permanently the greys and blacks with which he had before 1874 been able to create such superb effects. By combining the contributions of Impressionism with what visits to museums had taught him, he created works such as *A Bar at the Folies-Bergère* where novelty unites harmoniously with tradition, where the blurred, the impalpable, the fleeting wonder of the moment, co-exists with the solid, the stable, in a picture which is at the same time astonishing and strongly composed.

Impressionism

The painting, which a writer in 1874 in the review *Charivari* labelled "impressionist", had already existed for several years, when it acquired its name. The very picture

that inspired this label, the famous Port of Le Havre, which Monet had called *Impression-Sunrise,* was painted in 1872. The origins of impressionist painting go back to the middle 60's. Monet was at that time working at Paris, in the forest of Fontainebleau and on the Normandy beaches. He had listened to the advice of Boudin and Jongkind and reflected on the pictures of Corot, the Barbizon painters and Courbet. His friends, Renoir, Pissarro, Sisley and Bazille, admired much the same painting as he did and were moving in the same direction.

After the *Olympia* scandal, all these artists grouped themselves around Manet. They were, however, more inclined to approve the attitude he adopted towards official painting than to follow the example of his style. Monet showed it very clearly when in 1866-1867 he painted his *Women in the Garden.* To begin with he painted his picture entirely in the open, which was in itself a new departure. Also, he no longer indicated shadows over faces and bright clothes by the use of dark tones but replaced them by cold colours, greens and blues; in doing this, he set up an interplay of colours independent of the shape of objects, which even tended to upset and dislocate them. Certainly in the *Women in the Garden* the dislocation of objects is only indicated, the atmospheric veils are barely perceptible before these large figures that he observes close up. Monet had not yet abandoned a form of drawing whose clarity belongs

to a tradition of painting in the studio, rather than in the open. Also this new method becomes more emphatic in the landscapes which Monet and Renoir painted in 1869 of the famous *Bathing-place of la Grenouillère,* because there they viewed figures from a distance and were able to concentrate their attention on the play of light and atmosphere, which were to become the principal elements of impressionist painting. A period spent in England, during the Franco-Prussian War of 1870, was responsible for hastening Monet and Pissarro's development. For in London, the two artists saw Constables and Turners and if they did not admire them unreservedly, they found in their work affinities and encouragement.

The first exhibition which in 1874 gathered the representatives of the new school of painting together in Paris, at the studio of Nadar the photographer, is for the history of art an event of such importance that one tends to think its organisers too realised its significance and wished to stress it to the public. This was not so. The artists who took part in this exhibition presented themselves to the Parisians under the simple title of a *Limited co-operative company of painters, sculptors, engravers, etc...* They did not think of drawing up a manifesto. They did not want to establish a school. Besides, they did not all belong to the same tendency, nor did they all show the same qualities. In fact thirty of them exhibited and eight of them only—Monet, Renoir, Pissarro,

Sisley, Berthe Morisot, Guillaumin, Degas and Cézanne—were to become famous as Impressionists (Bazille was no longer one of them: he had been killed during the war of 1870).

Does this mean that these formed a homogeneous group? Their temperaments differed and their interests, as we shall see, were on certain points opposed. But what they had in common was the rejection of all that was dear to academic painting, historical, mythological and sentimental subjects, over-polished finish, dull tar-like colours. They also shared the determination to produce contemporary painting; they took their subjects from the everyday reality of their time and tried to express their sensations with sincerity, even should this force them to go against the rules of time-honoured tradition. To a certain extent they were all agreed in wanting to put on canvas, not what the painter knows of things, but only what strikes him at the precise moment when he paints. Besides, most of them showed a preference for the hazy landscapes of the Ile-de-France, for skies continually being transformed by cloud, for the shimmering reflections on the moving waters of the Seine and the Oise.

The analysis of luminous phenomena led them to break new ground in the field of technique. They limited their palette to the colours of the spectrum and took into account the laws of complementary colours. Knowing that complementary colours applied side by side heighten each other, whereas if mixed destroy each other, they applied their colours pure, in little dabs and accents without always avoiding, it is true, their crossing and confusion; for their principles were applied instinctively and not systematically. Nevertheless their painting became much lighter than that of any of their predecessors since Leonardo da Vinci and they gave the world outside a freshness, a youthfulness and, more than anything else, a variety of light effects that had never been known before in Europe.

Claude Monet

No one represents Impressionism better than Monet (1840-1926), no one has illustrated it with greater boldness, more logic and less compromise. Does this mean that his work embodies its theory better than anyone else's? He said: "We paint as a bird sings. Paintings are not made with doctrines." These utterances, which are often quoted, should not be taken too literally. Speculation did unquestionably have a place in his art, a painterly speculation, of course, in which instinct played a part as much as conscious research. After all, Monet was the painter of series and the first of these, the *Gare Saint-Lazare* at Paris, dates from 1876.

1876 was the Argenteuil period, the most "naïve" period of Impressionism. Monet had just completed on the Seine or in its neighbourhood some of the most successful works of the new painting.

What then made him change his subject and choose one that seems at first sight far less picturesque than those he had painted up to that point? Probably it was this very lack of picturesqueness that attracted him. Great artists have often set themselves the task of finding beauty and poetry where they are least apparent. But the Gare Saint-Lazare gave him the opportunity of studying an even more fugitive element than water: the smoke from engines. The haziness of this smoke, its capricious meanderings, its fairylike iridescence, the changes that it made on metal surfaces and the neighbouring houses—how could all this fail to fascinate him?

The term "free" series has been similarly applied to these works as to the *Break-up of the Ice* paintings that Monet did at Vétheuil in 1880. Ten years later, the "systematic" series appeared, the most significant of which was the one of *Rouen Cathedral* (1892-1894). It comprises more than twenty variations, always of the same façade, nearly always seen from the same angle. Nothing illustrates more clearly that the essential thing for him was not the subject, but the effect it produced at different hours of the day, in fair weather or cloud, in clear air or mist. Never before had anyone changed their position so little and discovered so many facets in a single subject; or rather, never before had anyone caught with such sensibility the miraculous and multiple reality of light and atmosphere. These natural appearances fascinated the artist so much that he sacrificed the substance, consistency and weight of things; the façade of the cathedral is reduced to a subtly coloured veil and there remains only an evanescent reminder of its structure.

This blotting out of the shape itself becomes even more accentuated in the various pictures Monet painted of the *Houses of Parliament* in London at the beginning of the century. Surrounded by either a blue or purplish fog in which an ethereal sun dissolves its yellows, its oranges and its pinks, the building itself is nothing but a ghost that looks as if a mere breath of air would be sufficient to shake it. One is reminded of Turner, although Monet is far from possessing his romanticism; for although it is true that there was a visionary in him as well as an observer, it is no less certain that he was careful not to engulf the world in his dreams.

When in 1899 he began painting his *Water-lilies,* his point of departure was still nature. The water garden, which he designed himself in his property at Giverny, provided him with the subject. If, at the beginning, objects are still easily identifiable, the vegetation of the pond and on its banks, the water-lilies, the jonquils, the wistaria, the weeping willows later take on vague shapes and the paintings show us above all blobs, trails, flourishes and tangles of colour which have a strong tendency to be sufficient in themselves. So, at the end of his life, Monet was far

from the realism, far even from the impressionism of the Argenteuil period. The *Flower Garden* and the *Pond with Wistaria* suggest certain abstract painters of today. This is why his work has recently enjoyed a fresh interest after being long neglected for a more geometric painting.

Alfred Sisley

Sisley (1839-1899) at the outset was close to Corot and even when he allowed himself to be led towards Impressionism by Monet, he still did not stray far from his master. However, if his senses were as easily awakened and his conception no less tender than that of his predecessor, his colours are more differentiated, as they owe less to fancy than to observation.

He lived and went about in the Ile-de-France, particularly in the Fontainebleau area; here he painted a river bank or a canal, a road leading either towards a village or fading away in the distance, there a village shrouded in soft light by the snow or invaded by the muddy waters of a flood. But whatever his subject, he observed it with calm. The flood as he saw it was not a disaster; clouds which, from the depths of the horizon, climb into the heavens do not bring lightning or rain in their wake; they are not upset by the storm and generally they move at a leisurely pace; one would suppose that their only object was to filter the light and to allow the air to preserve its freshness, and to

rid the colours of the world of their sharpness.

Until around 1877, Sisley was a master at expressing shades of meaning and subtle transitions. However, fired by Monet's example, he wished in his turn to increase the liveliness of his colours. From then on he forced his temperament and was generally less convincing. By losing his restraint, his art lost some of its exquisite delicacy, its distinction and very often its truth.

Camille Pissarro

Like Sisley, Pissarro (1830-1903) began by being under the influence of Corot and like him he was later guided by Monet, both towards Impressionism and towards the assertion of his own personality. Pissarro and Sisley also possessed a similar sensibility, although one finds in the former's work a note of anxiety which is lacking in that of the latter.

Up to 1884, Pissarro sought his subjects particularly around Pontoise. Sometimes, he set up his easel on the banks of the Oise, or at the corner of a road, sometimes he stopped by a farm gate opposite a peasant coming home from the fields or a woman pushing a wheel-barrow, sometimes he settled in a field where harvesting was in progress, or by a group of houses half hidden by trees. These he loved, not only because of their green touches in contrast to the red roofs, but also because of the lines their trunks and

branches would design over the canvas. Despite his Impressionism, Pissarro does in fact remain the advocate of a certain amount of structure and solidity.

In 1886, Pissarro allowed himself to be drawn beneath the banner of Neo-Impressionism. He soon realised that he had made a mistake and that his painting had become too systematic and in consequence dried up, so he regained his freedom.

During his last years, he at various periods painted scenes of towns (Paris, Rouen, Dieppe). While looking down from a window onto the avenues, boulevards, bridges and quays of the Seine, he embraces vast spaces and draws us into deep perspectives, thus giving his paintings that breadth and grandeur of vision which one associates with the name of Paris. The treatment is freer and wider than in the work of the 1870-1880 period, the colouring is often warmer and sometimes the drawing is very elliptical. Nevertheless, for him objects still exist; unlike Monet, Pissarro remained faithful to the realistic origins of Impressionism.

Auguste Renoir

Monet, Pissarro and Sisley are above all landscape painters. Renoir (1841-1919) is mainly, if not entirely, a painter of figures. He too made a religion of light; he brought it into play in each of his pictures, but rather than attempt to catch it, when fleetingly it alters skies, water, grass and trees, he took pleasure in seeing it caress the face or the naked body of a young woman. Furthermore, although he wanted the light to penetrate bodies, he did not want them to be dissolved in it. Their volume and to a certain extent their balance meant much to him.

In this respect his position offers certain analogies with that of Manet, whom he also resembles in the attachment which, although he was an innovator, he always felt for tradition. Like Manet he admired Titian, Velasquez and Delacroix, but he showed equal enthusiasm for Rubens and Boucher. The sensuality which he found in them was dear to him, which did not mean that it was of the same nature as his. Rubens and Boucher hardly ever painted a nude without suggesting the idea of forbidden fruit. To Renoir on the other hand nakedness seemed a natural state. If Eros is present in his work it is a pagan Eros and not the one to whom Nietzsche referred: "Christianity gave him poison to drink, which did not kill him", added the philosopher, "but degenerated him and led him to vice." Nothing could be further from vice than Renoir's nudes, there is nothing lewd or frivolous about them. In fact, these delicately pearly bodies do not seem even to have known the fevers of passion. They are before us in the state of innocence of a quiet animal life, unless they evoke the full and peaceful existence of flowers and fruit.

In this art we find no trace of torment, of intellectual anxiety or of psychological

complications. Even in the portraits we are in the presence of radiant faces, which express nothing else than the pleasure of living openly beneath a light which is both soft and intense. Most often in fact they are portraits of young women. Renoir's woman is Eve living in a paradise, where neither the tree of knowledge nor the serpent exist.

Something of paradise remains about her, even when she puts on the dress of the young Parisienne, when she goes dancing beneath the trees of the Moulin de la Galette, or when she is listening to a concert or trying on a hat at the modiste. All the same, she very much belongs to the period in which she was painted. Whoever wants to learn about Parisian society under the reign of Napoleon III or in the first years of the Third Republic and wishes to know what they wore and how they amused themselves, should turn as much to Renoir as to Manet.

Although he had painted a number of works that are among the masterpieces of Impressionism, towards 1883, Renoir believed himself to have reached a deadlock. A long journey to Italy during which he greatly admired Raphael and the frescoes of Pompeii led him to think that he neither "knew how to draw or to paint". He then decided to concentrate more on draughtsmanship and for several years he concentrated on it too much; his painting became harsh, his colours "acid", his light stiff and his composition too contrived.

However, he came through this crisis rejuvenated and matured. He removed the hardness from his drawing and yet gave a new firmness to form. His light was no longer rigid, nor did it regain its flickering quality. In the past it had merely bathed his bodies, now it impregnated them deeply and Renoir, who lived mainly in the south of France from 1897 on, liked to show them under a hot and ardent sun which ripened them like peaches.

When he imagined scenes in which women were relaxing, he no longer thought of the pleasures which town people enjoy; he thought of the more Dionysian ones that the human being finds when he escapes from the social conventions, in order to become one with nature. The bodies are now opulent, too much so, one might say, were it not obvious that the artist was looking for something more than mere prettiness: it is the exaltation of life, generous, primitive and vital. However, if everything in these last works is invaded by the same intoxicating light, if the blood which flows through the flesh of these women and the sap which circulates in the trees and plants appear to have a common source, the bodies still do not dissolve into the landscape; they enrich it with supple forms and precise rhythms, while keeping their vigour and solidity.

Edgar Degas

Although Degas (1834-1917) belonged to the impressionist group and showed at

nearly all their exhibitions, he had very little in common with either Monet or Renoir. He rarely painted landscapes and had little interest in the out-of-doors. He looks for the instantaneous in the movement of a human being or a horse; the light which he analyses is preferably indoors and often even artificial. He is more of a draughtsman than a painter, whereas generally the Impressionists drew very little.

His artistic formation, too, led him to express himself primarily in line. He had been the pupil of one of Ingres' disciples and he made several trips to Italy where he studied the masters of the Quattrocento (Pollaiuolo, Botticelli, Mantegna) more than Raphael and Michelangelo. The eagerness with which he tried to understand the artists whom he admired did not prevent him, however, from having very advanced ideas fairly early on. As early as 1859, he wrote in his notebook, "No one has ever done buildings or houses from below, beneath, or at close quarters, as one sees them when passing in the street." He conceived the idea of executing series of pictures on the same subject; for example, musicians, dancer or lighted cafés. Before actually beginning on these subjects, he painted for the most part cold, legendary and mythological compositions as well as portraits, which are not without distinction.

The theme of horse-racing is the first of those he borrowed from contemporary life. Although he began to paint them in 1862, it was not until 1873 with *The Carriage at the Races* that he gave an interpretation which clearly revealed one of the most characteristic aspects of his art: the unexpectedness of his layout. Undoubtedly such an unusual composition shows that he studied Japanese prints and looked at the work of photographers around him. It is no accident that his painting possesses much of the snapshot.

This characteristic was accentuated in the racehorses he painted the following year. He limited himself to the essential more and more and his form became more and more simplified. Anxious to increase the variety of postures and movements, he did not actually paint the race itself, but the moments which preceded it, when waiting for the start made the horses and jockeys nervous.

As for the movements of the human body, he studied them by observing the dancers of the Opéra. It is significant that he shows them oftener in the anteroom or practice room than on the stage itself; he looked less for their graceful movements than for their more unusual attitudes. He also always tried to vary his angle and choose one which made even the commonplace striking. This search for the unusual also led him to study the effects of artificial light—in a café entertainment, a theatre or the Opéra. Nor did he limit himself to capturing the strangeness of the white light and green shadows, which gas-light throws on to a face or an arm. He used this type of light to disjoint conventional

space; using shadow to narrow it, light to widen and deepen it. He likes to dispense with landmarks; our eye is often plunged from the foreground towards the back, without being at first sight able to gauge the distance which it has covered. This results in a feeling of poetic bewilderment which is accentuated by the boldness of his cutting off.

Anxious to go on discovering new aspects of that part of reality which attracted him, Degas penetrated into milliners' shops and into rooms where yawning women ironed. He surprised women in their privacy, drawing them while they are squatting in a tub, busy washing themselves, getting out of their baths, attending to their toilet. If, however, his art is indiscreet it is not sensual. Degas observes with curiosity but without desire. Unlike Renoir he does not glorify nakedness, he does not show it as a natural state; on the contrary, he always makes one feel that it will only exist for a few seconds and that soon clothes will hide it again.

"No art is less spontaneous than mine," he said. It is true that Degas does not record the impressions that chance brings his way; he chooses them, analyses them and then transposes them in a reflective and determined style. From 1880 onwards, he made more and more use of pastel which allowed him, in the most direct manner possible, "to be a colourist with line". At the same time, he strengthened his colours, and the vitality of his cross-hatching, the width of his colour patches, the freedom and the glow of his tones, and the singularity of his harmonies never ceased to increase.

Paul Cézanne

Though Cézanne (1839-1906) had moved since 1861 in the same circle as the future Impressionists, his painting had no connection with theirs for another ten years when he settled at Auvers-sur-Oise and listened to Pissarro's advice. Only then did the stormy style of his first period disappear and he painted peaceful landscapes in serene colours. But he was already less attracted by the fugitive than the permanent; he already refused to allow the form of objects to be blurred by the enveloping atmosphere. He consistently emphasised the structure of the painting and for this the houses, rocks, tree-trunks, everything that is massive, solid and can be defined by geometric lines were an essential element in his works.

For Cézanne to fulfil himself, he had to leave Paris and go to the south of France, where the dry and transparent air allows nature to appear at its clearest. He went in 1878 and lived there more or less continuously until his death. He worked around Aix, his birth-place, Gardanne and at l'Estaque. His originality is obvious in each of his pictures, but it is particularly striking in the landscapes which he painted of the Bay of Marseilles. The Mediterranean and the sky occupy their natural place, but they are firmly supported by a

framework of stable elements. There is little movement and there are few reflections in the sea; Cézanne did not enjoy the play of shimmering waves so dear to Monet. His water tends to be solid and the same applies to grass and foliage. His light is neither gay nor changeable. Colour does not translate fleeting moments, however attractive they may be. His colours are less iridescent than those of the Impressionists, less superficial too; it is almost as if the artist drew them out of the objects themselves.

Actually, in Cézanne two contradictory tendencies were at war and were the cause of the slow and painful painting of which he complained throughout his career. On the one hand, he wanted to transcribe his keen sensations of nature without losing any of their freshness and intensity; on the other, he was concerned with going beyond the disorderly and the transitory: he wanted to clarify them, to organise them on canvas, consciously and intelligently. This second tendency finally dominated his work; he ignored the perishable matter of objects and pushed their forms towards the regularity and immutable perfection of geometric forms and gave colour an essentially pictorial value.

When he painted nudes, their flesh did not interest him, nor anything which excites a caressing sensuality; he used bodies to build a living architecture. When he painted fruit, one could believe that he had never tasted it; he ignored the pulp and flavour. But he gave their colouring such richness, their shape such purity and fulness that they were transformed into plastic elements of startling strength. In other words, when he deprived objects of some of the qualities that nature confers on them, it was to load them more heavily with the life given by art. The significant thing is that as nothing lends itself better to purely plastic research than inanimate objects, so we find numerous still-lifes in his work. One might even be tempted to say that Cézanne treats everything except landscapes as a still-life. Look at his portraits; they tend in no way to reveal the inner life of his subject. However, they move us by the quiet gravity of their colours, by the very stiffness of their appearance, which confers on them something majestic and solemn.

Towards the end of his life, Cézanne shows in his oils a freedom comparable to that which he had long shown in his dazzling water-colours. When about 1904-1906, he painted *La Montagne Sainte-Victoire* to which he had so often paid a moving tribute, his objects were less and less defined and merely expressed sensations of colour, of masses and planes. His lyricism did not, however, lead him to neglect structure; it only appears less obvious. It is no longer emphasised by lines, but evolves from the rightness with which the vibrating areas of colours are distributed.

"I have blazed the trail; others will follow," Cézanne said. Others came and were his followers. It was he who inspired

all the vital painting of the first half of the 20th century. The Nabis, the Fauves and the Cubists studied him with equal fervour.

Neo-Impressionism

It is rare to find painters like the Neo-Impressionists, who have such a clear idea of what they want; rarely have artists felt so strongly the urge to put their ideas and methods on paper. Not only did Paul Signac, a member of their group, publish in 1899 a long treatise *(From Eugène Delacroix to the Neo-Impressionists),* but in 1890, four years after the first public appearance of the movement, Georges Seurat, the leader of the new school, felt the need to define his aesthetic theories in lapidary terms.

There were to be no vague perceptions recorded approximately with "random brush strokes", Signac said to sum up. The Neo-Impressionists analysed closely what they saw and reproduced it by differentiating systematically between the local colour of the objects, the colour of the lighting and their reactions one upon the other. They carefully read Chevreul's book *The Law of Simultaneous Contrasts,* they knew the works of the physicists, Helmholtz, Maxwell and N. O. Rood, and did their best to take into account the teachings of science. Instead of blending colours, the Neo-Impressionists substituted optical blending. They placed their colours side by side, so that they should remain pure on the canvas and only combine in the eyes of the spectator, while preserving their luminosity and their glow. Their distinct touches were in theory meant to be "proportional to the size of the picture". They took the form of a small spot or point, which led to the coining of the word "pointillism". Signac, however, protested: "Neo-Impressionism does not make a *point,* but a *division*" of colour and "dividing ensures all the advantages of luminosity, colour and harmony..."

How did art adjust itself to so much logic? Unsuccessfully, one must admit, and a number of the Neo-Impressionist pictures became arid from having been executed too systematically. In fact what gave its importance to the movement was not its "precise and scientific method", but rather the part that it played in the freeing of colour, and the serious attention it paid to grouping and composition, both by line and colour.

During the years that saw the break up of the impressionist group (its last exhibition took place in 1886), and the development of the movement, its adherents often dreamed of the advantages that art could derive from its relations with science. Besides about 1886-1890, Neo-Impressionism was far from appearing a dead-end. The group around Seurat and Signac not only included Camille Pissarro and his son, Lucien, H.-E. Cross, Angrand, M. Luce and others, even Toulouse-Lautrec, Van Gogh and Gauguin followed it in practice although they rejected its theories.

Georges Seurat

"Writers and critics see poetry in what I produce. No, I merely apply my principles; that is all." When Seurat (1859-1891) said this, he was no doubt speaking sincerely about his experiments, but he was mistaken about the significance of his art, where fortunately the presence of the poetry is undeniable. Of all the Neo-Impressionists, he is in fact the only artist whose sensibility was never stifled by the rigidity of the system. This shows how vital that sensibility must have been and how much at ease in respecting the strictest of rules. Seurat was one of those artists who dislike pouring themselves out, are inclined to conceal their emotions and hide them under an appearance of coldness created by a careful composition and meticulous technique.

From early youth he knew to what tradition he belonged; he copied Ingres, Poussin, Holbein and Raphael. Although he also looked to Delacroix, it was not in order to admire his romantic outpourings, but to absorb the laws, which that artist applied in the field of colour. The same preoccupation led him to study *The Grammar of the Art of Drawing* by Charles Blanc. He discovered a sentence that impressed him deeply: "Colour reduced to certain, definite rules can be taught like music." Enthralled by the certainty of science, he also studied the works of Chevreul, N. O. Rood and David Sutter's *The Phenomena of Vision,* etc.

Before 1882, he drew more than he painted and throughout his life he remained faithful to black and white. The vibrant pages which he drew with a Conté crayon possibly reveal the most poetic and attractive side of his work. No less attractive are the small sketches he drew on the spot in a lively, free style. These rapid sketches did not satisfy him; he wanted a more complete art, which satisfied the mind while moving the eye. He wanted colour to be more "exact", shapes well defined whose volume could be felt, a volume that he suggested less by modelling than by the shaping of the outline. In addition he enjoyed arranging vast surfaces and filling them with numerous figures in varying attitudes. In consequence, the few large works, that his short life allowed him to produce took shape slowly. He took two years to paint *A Sunday Afternoon at La Grande Jatte,* this "manifesto" picture, which, when it was shown at the 8th Impressionist Exhibition, marked the "official" entry onto the scene of Neo-Impressionism.

Although there are innumerable anecdotal elements in this work, it is not these that are memorable but the style. One forgets that the women's clothes appear ridiculous and sees merely the beauty of the play of lines for which they are a pretext. Everything is radically transposed into the domain of pure art so that life appears suspended. Movements are frozen into strange postures. Time is abolished and the figures look like statues standing in

the still, rigid light of a museum.

In later compositions the rigour softens, light quivers more, colours become clearer and lighter. However precious these works may be, it was in his less ambitious ones that Seurat showed his finest qualities: the landscapes inspired by the Seine at Courbevoie, the sea at Port-en-Bessin, the harbour at Gravelines. In these, an impalpable delicacy is combined with masterly composition, and subtleties of vibrating colour with a sensitive precision of drawing.

If in the majority of his pictures Seurat shows little concern for movement, he makes it triumphant in *The Circus,* which was to be his last picture. However fierily the horse gallops, however momentary the positions of the acrobats, the painter is always in control. He shows us clearly defined figures surrounded by lines, which sometimes move with the subtle agility of a serpent and at others stiffen, break into acute angles or describe a rapid zigzag. Seurat's intelligence makes itself felt even in the way he painted the leaps. He always gives expression to the serene, balanced consciousness which distinguishes the classical painters, always contrasts irregularity and the confused richness of life with simplified, purified forms and clarity. He was to be admired by the geometrically minded artists of the 20th century, particularly certain Cubists, who valued the total effect of his taste for discipline, the intellectual side of his art and the deliberate restraint exercised over his sensibility.

Paul Gauguin

Up to the age of thirty-four, Gauguin (1848-1903) was nothing but an amateur painter, who was friendly with Pissarro and came under his influence. Then suddenly in 1883, in order to be able to "paint every day", he left his very lucrative job with a Paris stockbroker, turning his back on prosperity before finally turning it on his wife and five children. From then on, poverty, suffering and bitterness were to be his lot and the conviction that he had only followed his destiny both consoled and exasperated him.

In 1886, he went to live at Pont-Aven in Brittany, in the first place probably because he was looking for somewhere that was not, like Paris, "a desert for the poor man". But he also wanted to escape from civilisation. He already felt that the savage life was making him young again. The following year, he wrote, "I am going to Panama to live an unsociable life... I shall find new strength far from any human being." He went from Panama, which disappointed him, to Martinique where the nature enthralled him, but which he had to leave because of ill-health, so that at the end of the year he returned, worn out by illness, and with a heavy heart. He went back to Pont-Aven and now his painting acquired a new and personal stamp. He at last found himself with the help of Cézanne, Japanese prints, discussions with the young Émile Bernard and even

possibly through the latter's paintings.

"Do not paint too closely from nature," he told one of his friends at that time. "Art is an abstraction. Draw it out of nature, dream about it, and think more of the resulting creation. The only way to attain God is to do as the Divine Master, create." Consequently, he encircled his shapes with vigorous and synthetic outlines, he reduced modelling and only used the more dominating of nature's colours, which he spread on more or less flat. In addition, he dispensed with shadows, if he judged it necessary, abandoned aerial perspective and made scant use of linear perspective, suggesting depth mainly by planes and reference points of colour. Whether his subject was taken from reality *(The Swineherd, The Haymakers)*, or from his imagination *(The Vision following the Sermon)*, whether it was a portrait or a landscape, Gauguin in the treatment of his subjects was always inspired by the spirit of the world around him. "When my clogs resound on this granite," he said, "I hear the mute, dull and powerful sound which I look for in painting." It was not only from the granite soil, but from the simplified and rough sculpture of the calvaries, as well as popular art in general that Gauguin, which was unusual for his times, did not hesitate to draw his inspiration.

In the end Brittany was unable to satisfy him. His soul thirsting for the primitive life, as well as his poverty, made him look for the "promised land" elsewhere, further afield, and in 1891 he left for Tahiti.

Ill and penniless, he returned to France in 1893, but two years later he again set sail. In 1903 he died in the Island of la Dominique, in the Marquesas, where coming from Tahiti, he had settled in 1901. Although in reality the South Sea Islands were not the same as those he had dreamt of and living there he was spared neither suffering nor despair, it was there that his art found its supreme fulfilment. His forms became more ample, his drawing more forceful, his colouring richer and more harmonious. His works naturally took on an exotic character from the people and the vegetation he saw before him, but his exoticism was never merely picturesque; it expressed his feeling of life far more than it represented nature. He felt not as a primitive, but as a civilised European, who wanted to plunge himself into primitive life, which he regarded with nostalgia, fully realising that he could never recapture sufficient innocence to become a part of his Lost Paradise. That is why there is always in Gauguin's painting something melancholy and unsatisfied. The titles of some of his works *Alone, Nevermore, Where do we Come from? Who are We? Where are we Going?* underline the anxiety which consumed him. They also indicate the dangers that he was running and that he averted, because the interest of an idea never assumed greater importance in his work than its painterly realisation.

Just as he avoids the trap of literary painting, Gauguin in general avoids being purely decorative, which is extremely

difficult for a painter who stylises, gives up chiaroscuro, relief, and applies his colours in flat areas. By doing this he managed in his turn to prove that the traditional road of artists since the Renaissance was not the only one which offered a means of emotional expression. He demonstrated it and also proclaimed, "I went right back, further than the horses of the Parthenon, right to the gee-gee, the old rocking horse of my childhood." He also said that he wished to "take painting back to its sources" and even added "I wanted to establish the *right* to try anything." There words influenced 20th century painting as much as his works. Artists were to heed them and to be helped by them, even if they were not affected by his works.

Vincent van Gogh

Few careers were as meteoric as Van Gogh's (1853-1890). He was twenty-six when he dashed off those of his first drawings that be considered worth preserving, thirty-three when he started to discover his style and thirty-seven when he died. The reason for this late vocation is known. He started to draw out of despair, his life up to then having been one failure after another. The final blow, and the hardest to bear for this son of a Dutch minister, took place in the Borinage, where he had wanted to live as an evangelist among the miners. His inability to preach, as well as his "exaggerated" practice of Christianity, caused the removal of his licence. It was when everyone considered him a "good for nothing", that he turned to art, primarily no doubt because he wished to prove that he was "good at something", and probably even more because he wanted to find some way of showing the love he felt his fellow human beings. Far from being a game or a distraction, art for him was a mission.

Consequently then, it was not surprising that when he returned to Holland and lived in the country, he should become the painter of peasants. There is nothing surprising either in the fact that he admired and consulted Millet. But he also admired Zola and when towards 1885 his art took on a certain vigour, the author of *Germinal* and the painter of the *Angelus* both seem to have met in it. His figures were dignified and rough at the same time. His palette was generally dark and muddy, his style bold and harsh. Whatever may have been the value of the works painted in this manner, they would never have earned more than a national reputation for him. It was only when he came to Paris in 1886 that he won the place that is his in the history of modern art and became the beacon which in the 20th century lit the way for the Fauves as well as for the Expressionists.

Through his contacts with Pissarro, Gauguin and Signac his painting lost its peasant heaviness and sentimentaly. His colours brightened, his touch lightened, became fragmented and even at times poin-

tillist, he painted views of Paris, flowers, still-lifes and portraits, which strike one by their calm and by the airy character of their harmonies and by their relaxed drawing. Only in his self-portraits do we see that he was not entirely satisfied with Paris, his fellow painters and their discussions; in the end it all got on his nerves, and he felt the need for another change.

Attracted by the sun, he went in February, 1888, to live in Arles. He was thrilled by the south of France, he found it as "beautiful as Japan", which, of course, he had never seen, but which he imagined through the admiration he had for Japanese prints. Soon his stroke widened, his colours became heightened and his drawing firmer. He worked without sparing himself, in the hot sun, while the mistral blew, sometimes he even set up his easel at night in the middle of the fields. He was not satisfied with recording what he saw, he expressed the emotion of his whole being, the quivering of his heart and the inspirations of his mind. In order to intensify his expression, he exaggerated what seemed essential to him, and dismissed what he judged trivial or insignificant. Haunted by the sun, which he adored all the more intensely as he was from the north, he gives us a much more brightly coloured vision of the south than did Cézanne, who was a native of Provence. Pure colour triumphs also in his portraits, his flowers, his interiors. He intended to give it a symbolic value. He painted a *Café de Nuit,* where he "tried to express in red and green the frightful passions of human beings." He dreamed of expressing "the passion of two lovers by a mixture of two complementary colours, their mixtures and their contrasts, the mysterious vibrations of their related colours". At the same time he was engaged in drawing and he produced several works of considerable vigour with a pen or a reed. This man, who worked with spirit, tenaciousness and lucidity, neglected nothing.

His lucidity never deserted him even during his fits of madness, the first of which took place in December 1888 after a quarrel with Gauguin, which led him to cut off one of his own ears. Even at the lunatic asylum at Saint-Rémy, where he asked several months later to be admitted, between fits he was able to judge with clear-sightedness both his condition and his art. Although he no longer possessed the joyous colouring of the Arles period and his drawing became tortuous, whirled and appeared to be out-of-breath, although his works expressed a tearing anxiety and an incurable anguish, they were not the product of a delirous or of an uncontrolled hand.

Was there any difference in those he painted at Auvers-sur-Oise during the last two months of his life? In some of them his hand seemed to have lost a little of its assurance, although his creative force seemed in no way exhausted. What could be more masterly than the *Portrait of Dr Gachet*? What could be more expressive

than those broad landscapes with their threatening skies, vibrating with anxiety when they are not whipped by a fierce wind? Although his style was now more cursory than it had been, it remained full of vigour. It remained just as controlled and his paintings were still firmly composed in spite of the black despair that gradually drove him to suicide.

Henri de Toulouse-Lautrec

Artistic activity and destiny were as closely connected in Toulouse-Lautrec (1864-1901) as in Van Gogh and Gauguin. He was descended from the Counts of Toulouse and his father was an eccentric with a passion for hunting and horses. He broke both his legs in childhood, so that he grew up a crippled dwarf who could only walk with difficulty. This infirmity determined the flavour of his art just as it determined the course and details of his life.

Unable to lead the life normal to those of the class into which he was born, he very soon withdrew from polite society. He came to Paris in 1882 to pursue his studies. Three years later he settled in Montmartre, where he soon spent a great deal of his time at balls, cabarets and brothels. Nowhere, did he feel more at home than in this world of debauch and easy pleasures. His eye was so keen, his mind so disillusioned, his heart so filled with irony and bitterness that often the picture he gives of this world is cruel and pitiless. His heart revealed itself too in the way in which he represented movements, whether of his father's horses or those of the dancers of Montmartre. The faster and the easier these movements were, the more he observed them with passion. He looked at them with envy, with secret malice, managing to catch them at moments when they looked not merely strange, but grotesque. His sharp, biting, cruel drawing has a caricatural side, in the same way as his colouring has an aggressive acidity. In all this he differed from Degas, whom he admired. He is close to him, however, in his love of the unexpected, his indifference to nature, his taste for artificial lighting and the importance he attached to line.

In general, his models too are different from those of Degas. He did not look for them among young Opéra dancers; he found them at the Moulin Rouge, in music halls and circuses. Actually it was often he who contributed to their fame by making them appear striking and unforgettable in his posters, which plastered the walls of Paris.

His posters and lithographs are in general as excellent as his paintings. Often they are even more masterly than the latter. Their success is generally dependent on the suggestive vitality of their outline, where form is reduced to its simplest expression. When designing posters, Toulouse-Lautrec kept in mind Japanese prints, whose lessons he had assimilated better than anyone else. However, his brush was freer than that of the Japanese

artists and his expression more direct. Instead of the slightly stiff reserve of the Far East, we find in Toulouse-Lautrec's layout, drawing and choice of colour, an audacity which barely avoids disrepect and is even at times tinged with insolence.

It is the fate of all artistic movements to come apart at the end and to fall out of fashion. One must be careful not to deduce from this, however, that the path they followed was mistaken from the start and that the artistic style they advocated was never very important. Even when it had been cast aside and "surpassed" by succeeding generations, Impressionism remained fruitful for the pioneers who developed it. It should not be forgotten that Monet continued to work vigorously in this vein until his death in 1926.

Impressionism, too, created ripples that went far beyond its immediate circle. It exerted an influence in many countries, attracted disciples and gave rise to variations. Artists such as Liebermann, Slevogt and Corinth in Germany come to mind, as well as Claus and Vogels in Belgium, Breitner, Gabriel and the Maris brothers in the Netherlands, Sickert and Steer in Great Britain, to name only a few. It is true, of course, that works by these artists are generally not as new as those of the original Impressionists. The analysis of light and the division of colors are less developed or often are not even under-

taken. This is why the Impressionists who worked outside of France frequently never went beyond the stage that Monet reached about 1874. Nonetheless, their pictures are important at least on a national level for they served to give a new direction to the painting of their respective countries. The negative aspect is that many artists found in Impressionism only a stimulus to dash off easy and superficial works in the impressionist manner. But there is obviously no relationship between them and painters like Monet or Pissarro who always did something more than paint pretty sights for tourists.

To sum up, Impressionism has played a very important role in the evolution of contemporary art. All of the artistic innovations of the twentieth century, with the exception of Dadaism and Surrealism, have been either directly or indirectly influenced by it. Brief mention has already been made of the lessons that certain modern artists have drawn from Cézanne, Gauguin, Van Gogh, and Seurat. But the orthodox Impressionists also helped many painters who later followed divergent paths. Precisely, they encouraged them to reject academic schooling, to free themselves and to take the first steps in the direction that permitted them to accomplish their works. Among these artists, we can see on the one hand Fauves like Matisse and Dufy and on the other Expressionists like Ensor, Munch, Nolde, Kirchner, Heckel, Schmidt-Rottluff. Even Belgian painters like Permeke, De Smet

and Van den Berghe began by being "luminists". On the eve of World War I, Impressionism thus contained a revolutionary ferment whose effects were greater than are frequently supposed and could be felt even among abstract painters. Kandinsky, for instance, admitted that it was Monet's *Haystacks* that led him to doubt whether it was necessary to paint objects. Closer to us, certain informal artists have discovered affinities between themselves and the author of the *Water-lilies,* who is now seen as having a very contemporary relevance. Although Monet finally drew away from what his style had been during the heroic period of Impressionism, he did this without renouncing any of his preceding work; he simply went as far as he could and explored his possibilities to the end. Monet's first concern was what impinged on his retina but he also (freely) translated his intoxication during the last twenty years of his life. Yet this intoxication was caused by the infinitely varied effects of light that had fascinated him since the beginning.

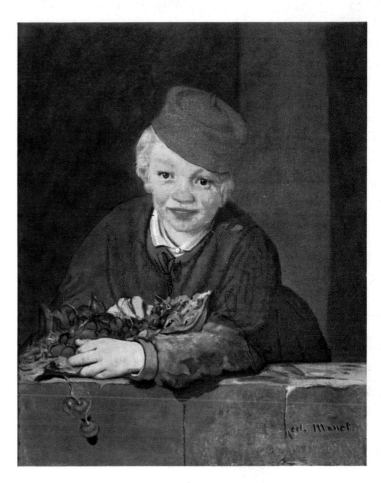

1
L'Enfant aux cerises.
c. 1858.
Child with Cherries.

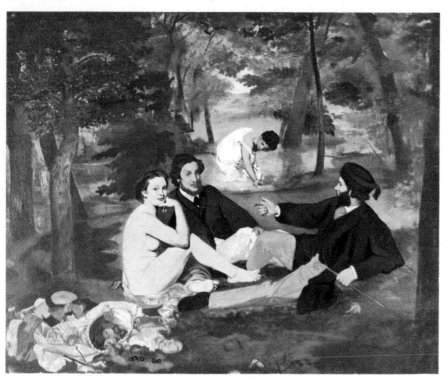

2 Manet. Le Déjeuner sur l'herbe. 1863.

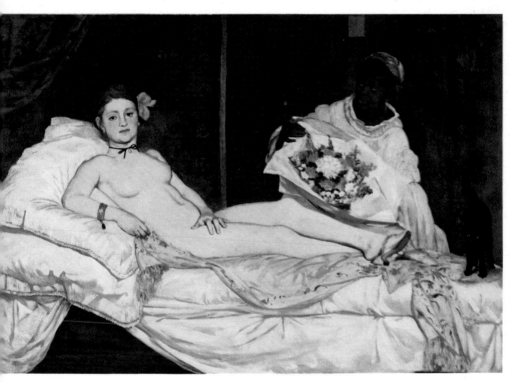

Manet. Olympia. 1863.

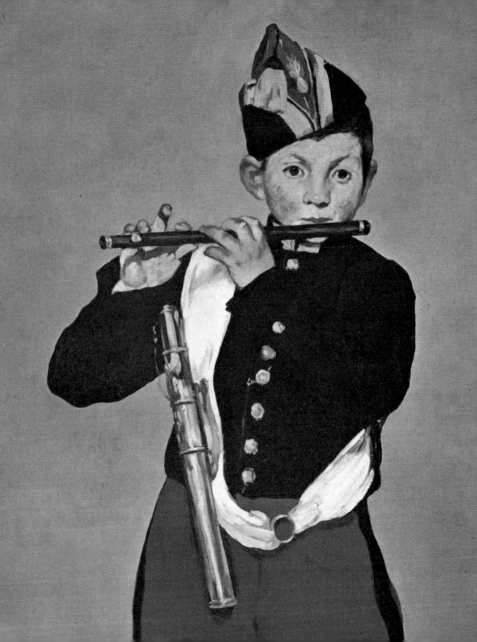

4
Manet.
Le Fifre.
1866.
Détail.
The Fifer.

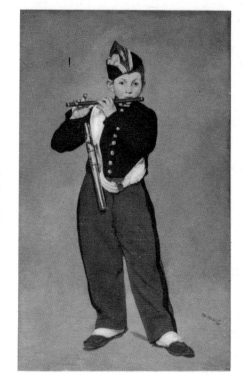

6
Manet.
Le Fifre.
1866.
The Fifer.

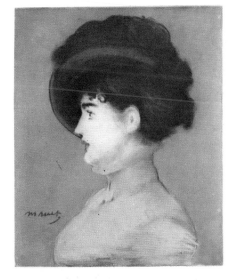

5
Manet.
Portrait d'Irma Brunner.
c. 1882.

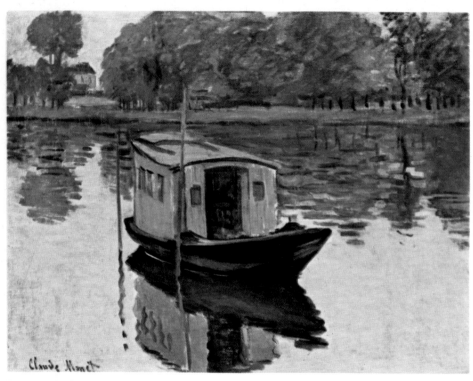

7 Monet. Le Bateau - Atelier. c. 1874. The Studio Boat.

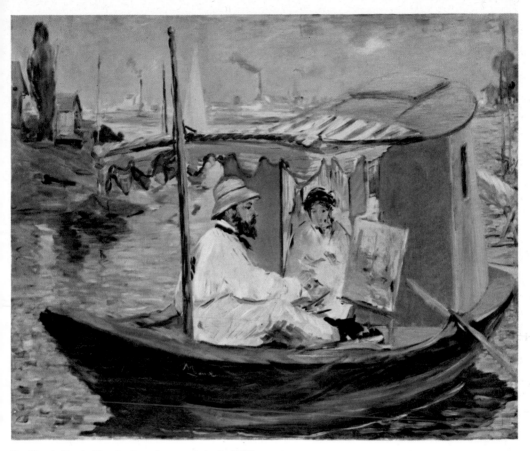

8 Manet. Claude Monet peignant sur son bateaŭ. 1874.
 Claude Monet painting on his Boat.

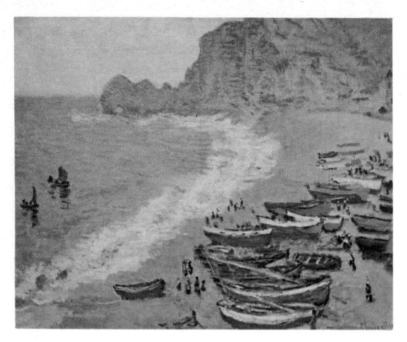

9
Monet.
Etretat.
1883.

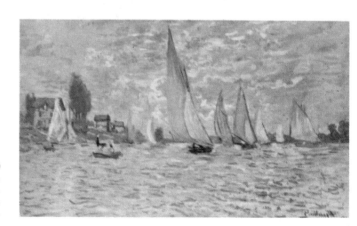

10
Monet.
Les Barques. Régates à Argenteuil.
1874.
The Boats. Regatta at Argenteuil.

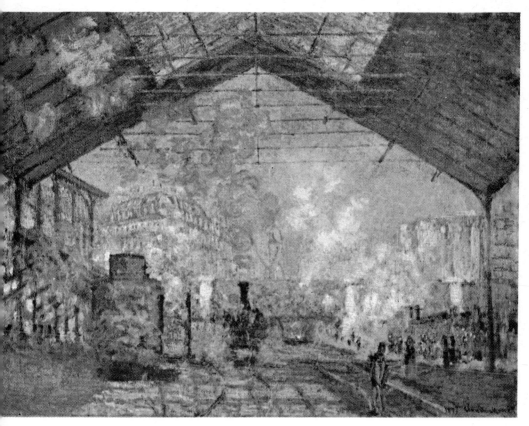

Monet. La Gare Saint-Lazare. 1877.

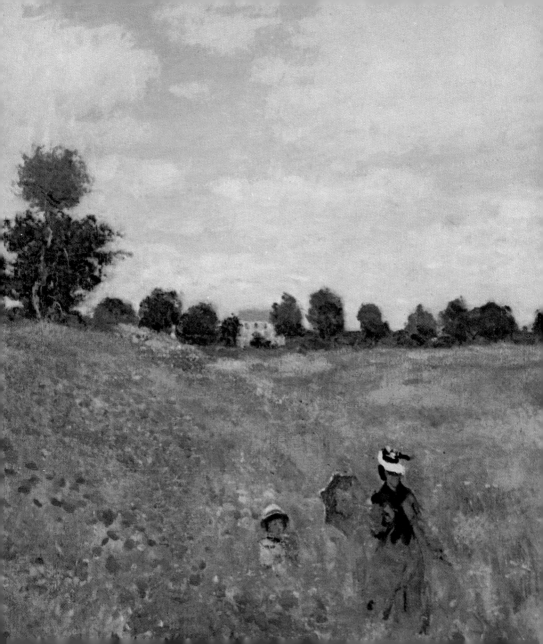

12.
Monet.
Les Coquelicots.
Détail.
1873.
The Poppy Field.

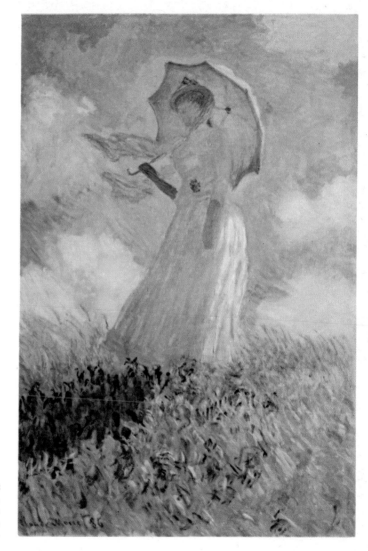

13
Monet.
Femme à l'ombrelle.
1886.
Woman with a Parasol.

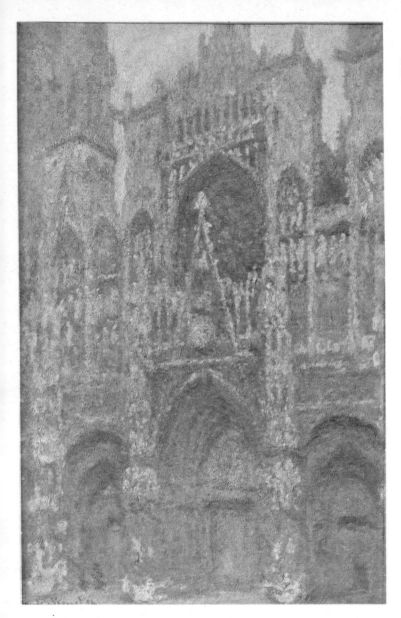

14
Monet.
La Cathédrale de Rouen.
Le Portail, temps gris.
1894.
Rouen Cathedral,
the Portal, Dull Weather.

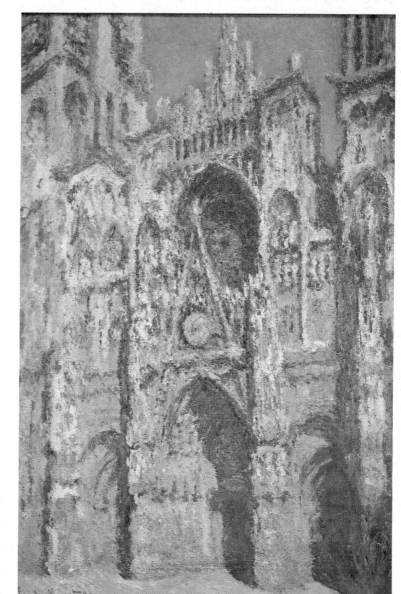

15
Monet.
La Cathédrale de Rouen.
Le portail plein soleil.
Harmonie bleue et or.
1894.
Rouen Cathedral.
The Portal, Full Sunlight,
Harmony in Blue and Gold.

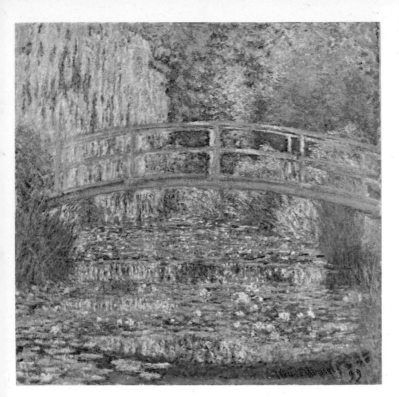

16
Monet.
Le Bassin aux nymphéas.
Harmonie verte.
1899.
Pond with Water-Lilies,
Harmony in Green.

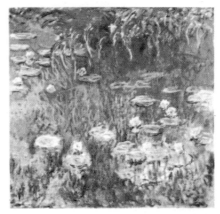

17
Monet.
Nymphéas.
C. 1910.
Water-Lilies.

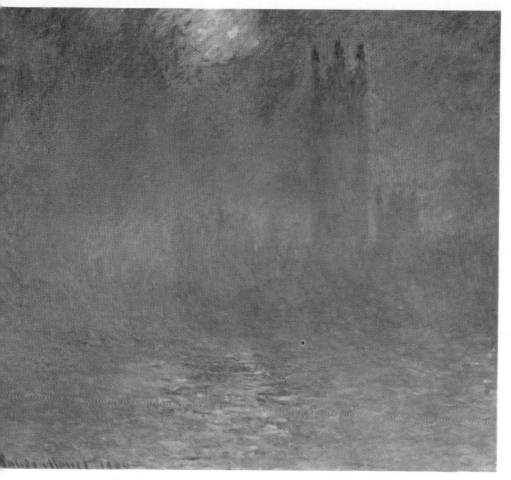

18 Monet. Le Parlement. 1904 The Houses of Parliament.

19 Monet. Nymphéas. Water-Lilies.

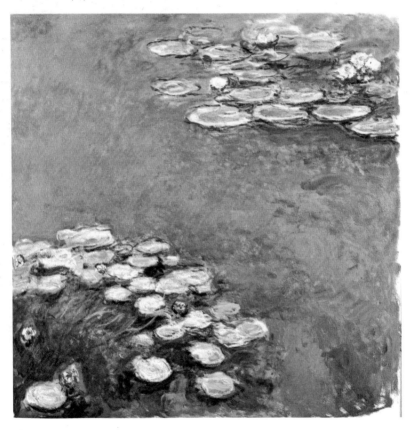

20 Monet. Nymphéas à Giverny. 1908. Water-Lilies at Giverny

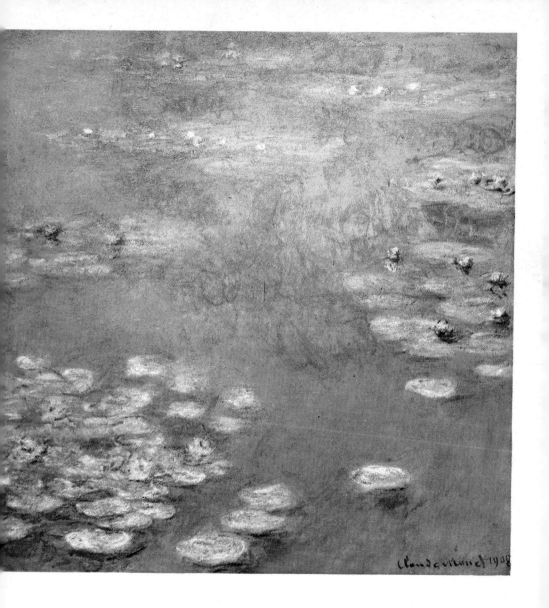

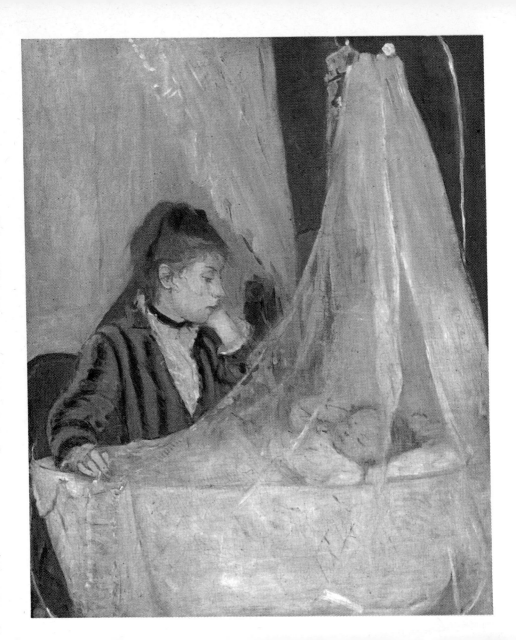

22 Morisot. Sur la terrasse à Meudon. 1884. On the Terrace at Meudon.

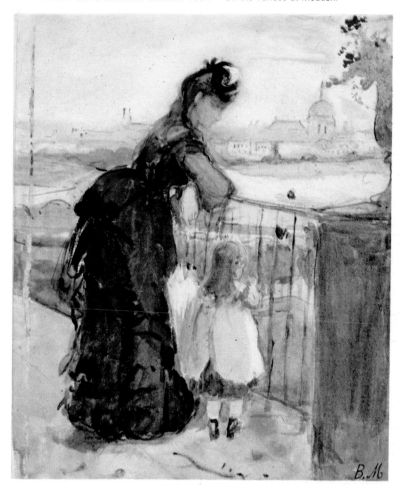

21
Morisot.
Le Berceau.
1872.
The Cradle.

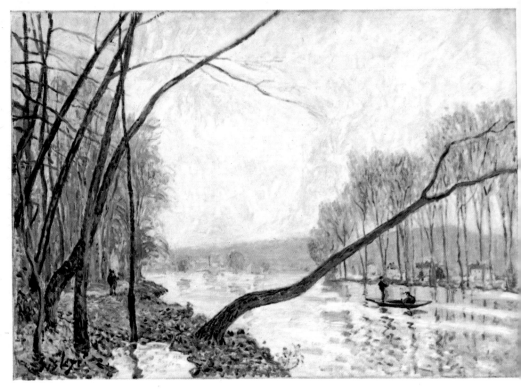

23 Sisley. Bords de Seine en Automne. Banks of the Seine in Autumn.

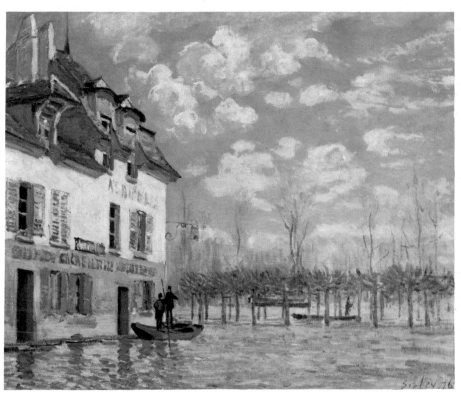

24 Sisley. La Barque pendant l'inondation. 1876. Boat during a Flood.

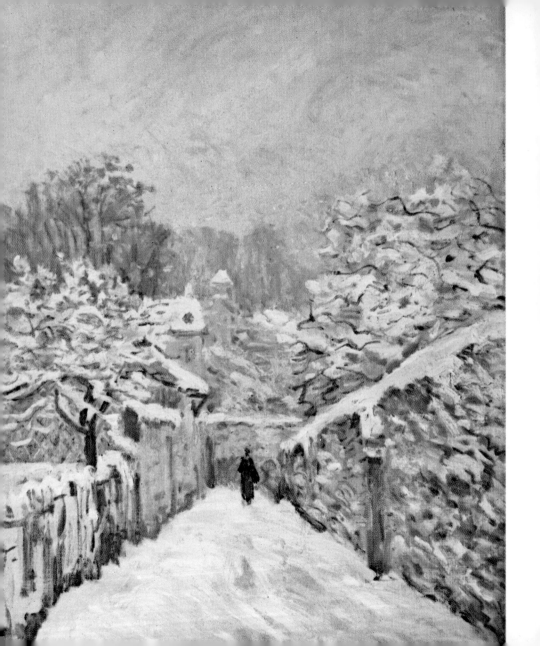

← 25 Sisley. La Neige à Louveciennes. 1878. Snow at Louveciennes.

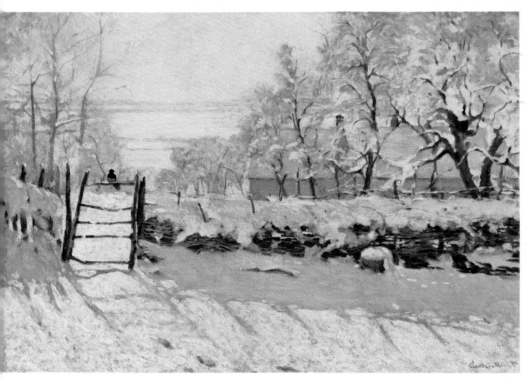

26 Monet. La Pie. c. 1870. The Magpie.

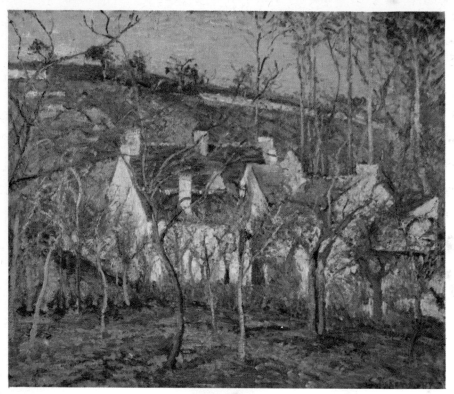

27
Pissarro.
Les Toits rouges.
1877.
The red Roofs.

28
Pissarro.
Entrée du village de Voisins.
1872.
Entrance to the Village of Voisins.

29
Pissarro.
Jeune Fille
la baguette.
1881.
Girl with
a Twig.

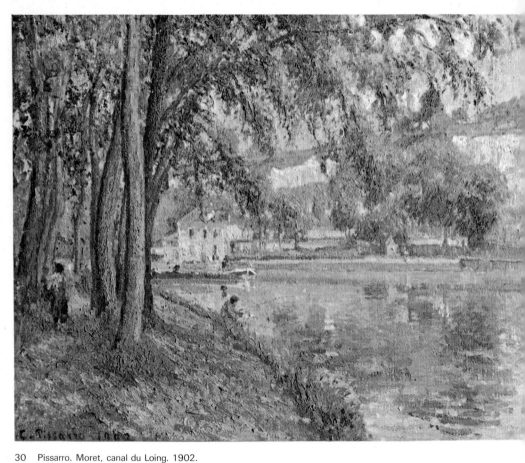

30 Pissarro. Moret, canal du Loing. 1902.

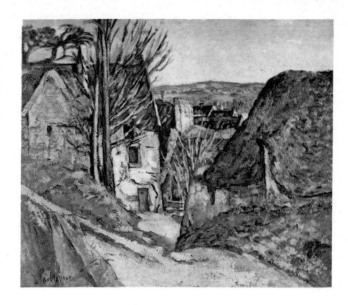

31
Cézanne.
La Maison du pendu.
1873.
The House of the Hanged Man.

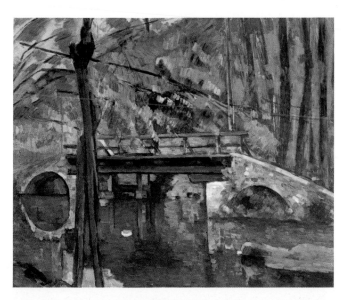

32
Cézanne.
Le Pont de Maincy.
1879.
The Bridge of Maincy.

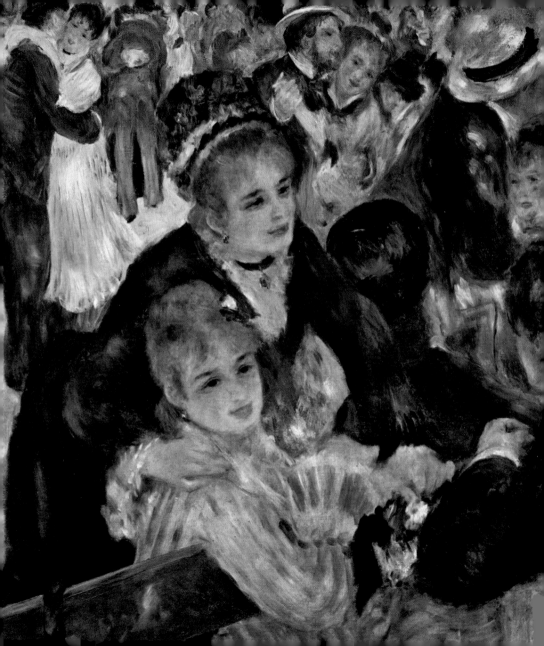

33
Renoir.
Le Moulin de la Galette.
1876.
Détail.

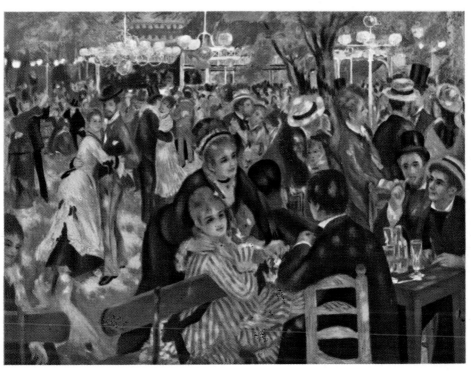

34 Renoir. Le Moulin de la Galette. 1876.

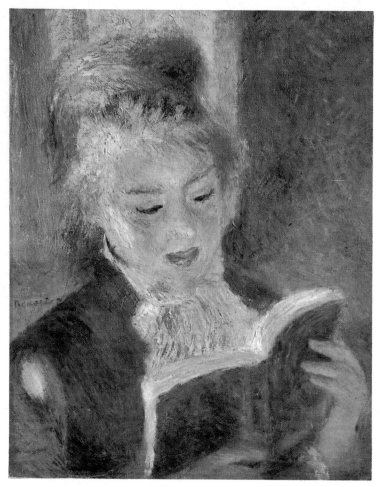

35 Renoir. La Liseuse. 1874. Girl Reading.

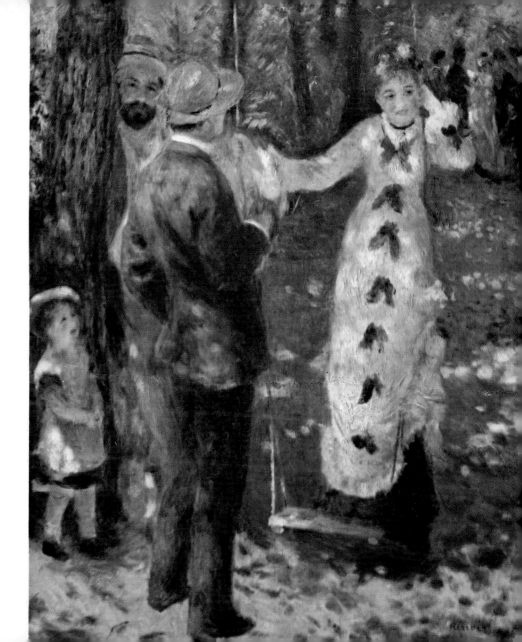

39 →
Renoir.
Deux Jeunes Filles dans les prés.
c. 1895.
Two Young Girls in a Meadow.

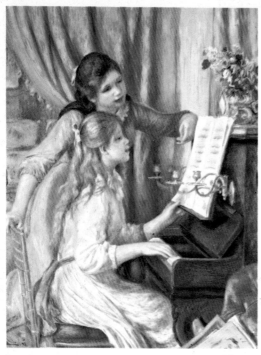

37
Renoir.
Jeunes Filles au piano.
1892.
Young Girls at the Piano.

38
Renoir.
Le Bain.
1890.
The Bath.

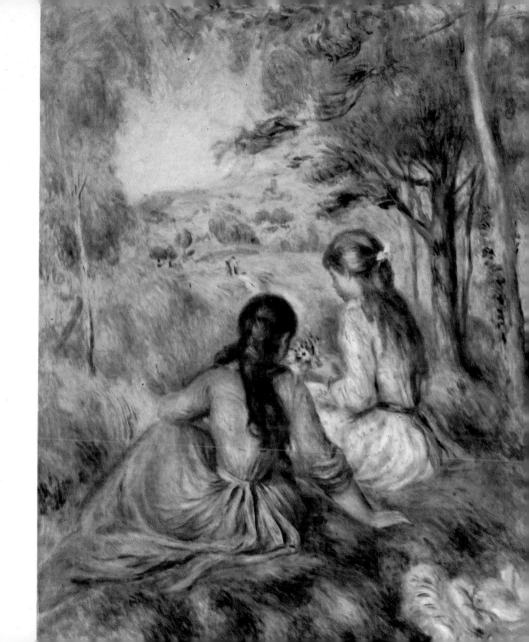

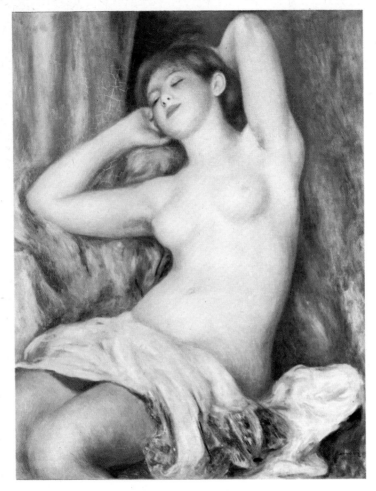

41
Renoir.
Fillette au
chapeau bleu.
18891.
Young Girl
with a Blue Hat.

40 Renoir. La Dormeuse. 1897. Sleeping Woman.

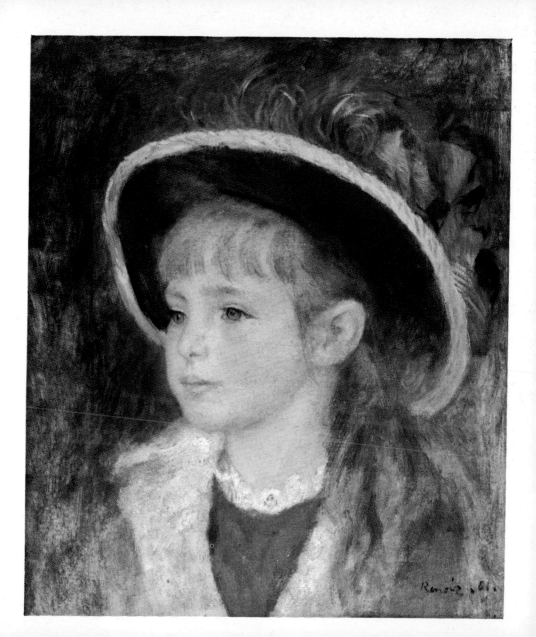

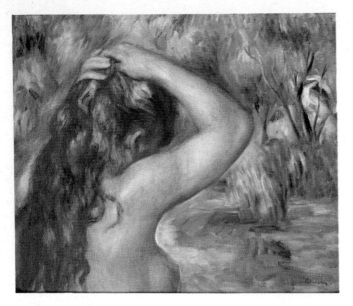

44 →
Renoir.
La Première Sortie.
c. 1875-1878.
Her First Evening out.

42
Renoir.
Jeune Fille attachant ses cheveux.
c. 1892-1895.
Young Girl fixing her Hair.

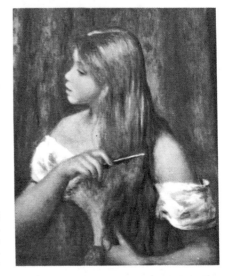

43
Renoir.
Jeune Fille se peignant.
1894.
Young Girl combing her Hair.

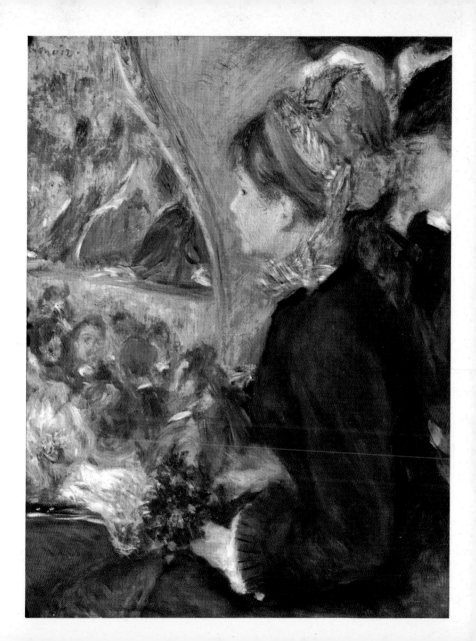

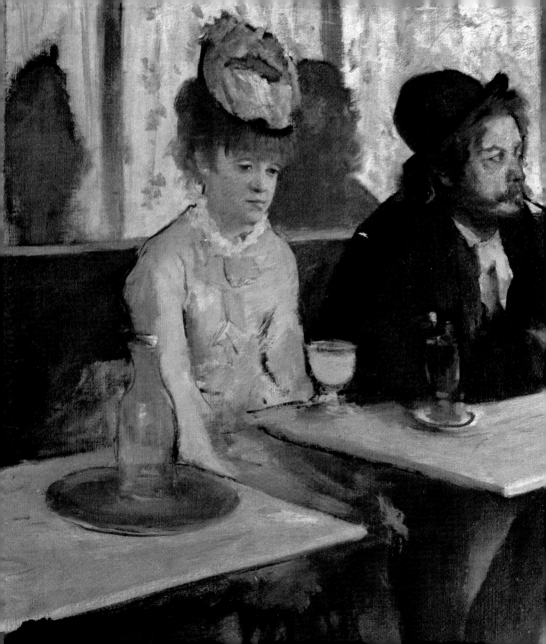

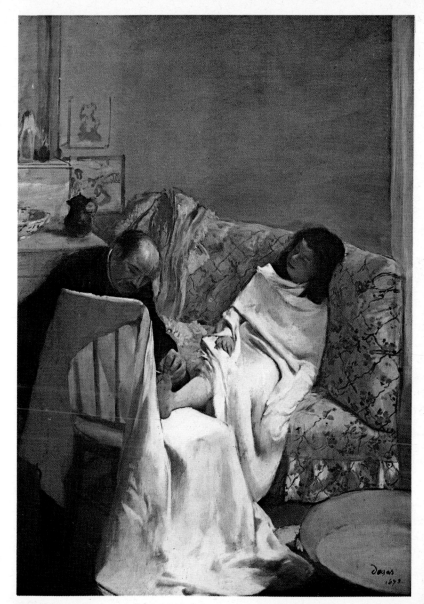

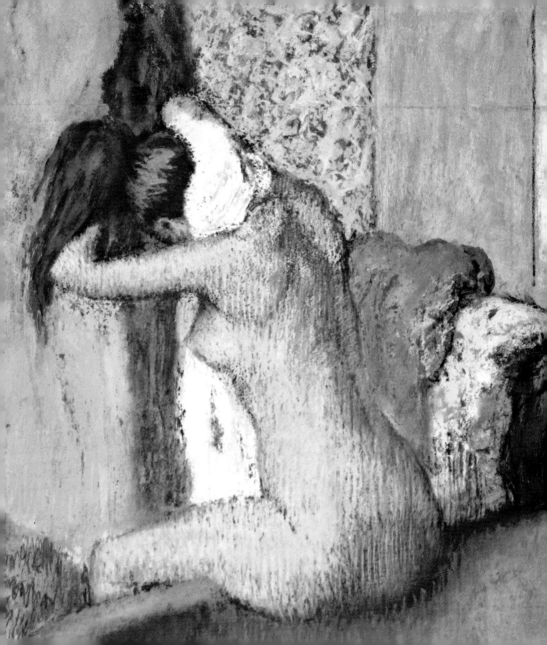

47
Degas.
Après le bain,
femme s'essuyant
le cou.
1898.
After the Bath,
Woman drying
her Neck.

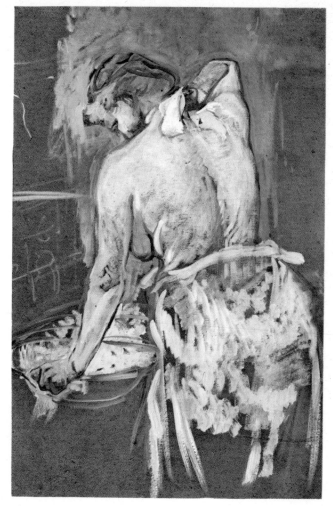

48 Toulouse-Lautrec. La Toilette. 1896.

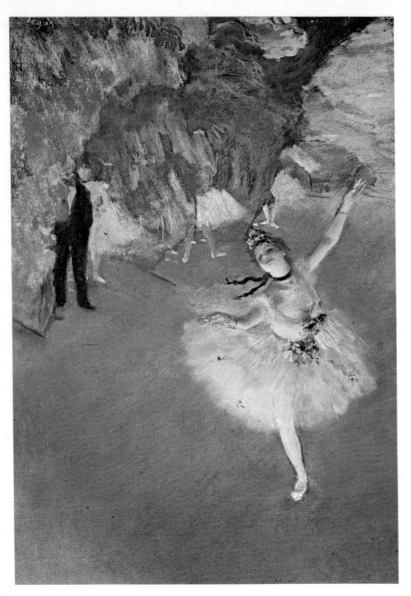

49
Degas.
L'Etoile ou
La Danseuse
sur la scène.
1878.
The Star
or Dancer on
the Stage.

51
Degas.
Deux Danseuses à la barre.
c. 1900.
Two Dancers at the Practice Bar.

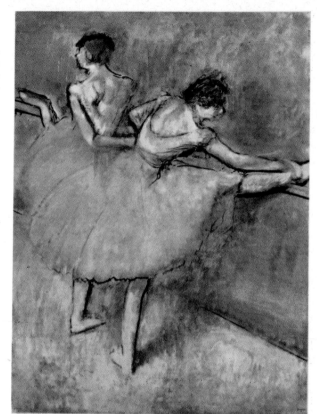

50
Degas.
Danseuse au tutu rose.
c. 1880.
Dancer in a Pink Dress.

52 Degas. La Voiture aux courses. 1870-1873. The Carriage at the Races.

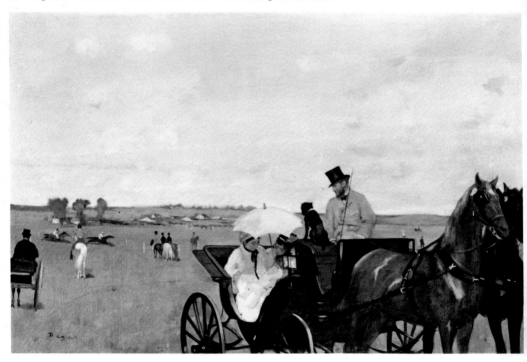

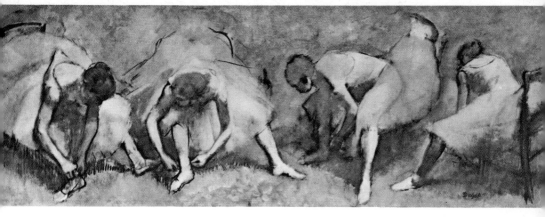

53 Degas. Danseuses ajustant leurs chaussons. c. 1883. Dancers fixing their Slippers.

54 Degas. Trois Etudes de la tête d'une danseuse. c. 1886-1890. Three Studies of a Dancer's Head.

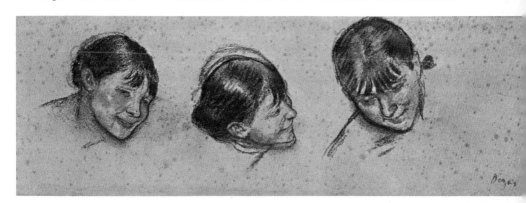

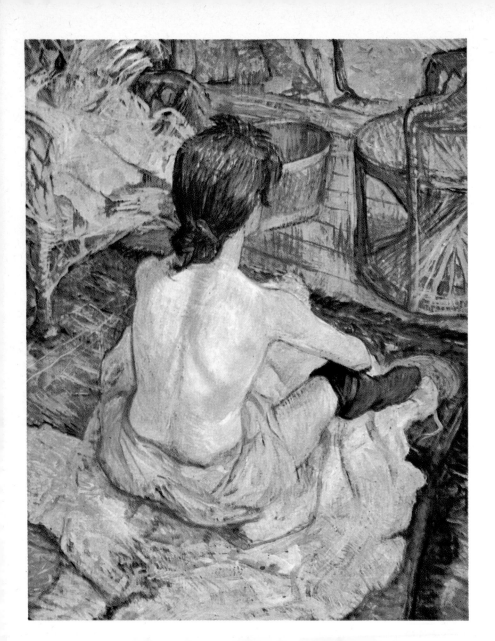

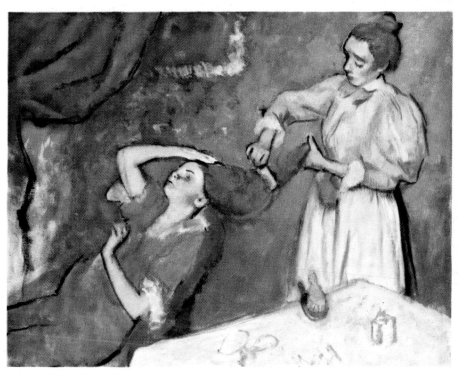

56 Degas. La Coiffure. 1892-1895.

- 55 Toulouse-Lautrec. La Toilette. 1896.

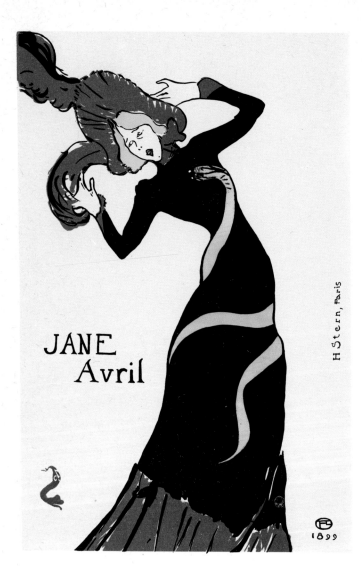

JANE
Avril

1899

H Stern, Paris

58
Toulouse-Lautrec.
La Goulue entrant
au Moulin-Rouge.
1892.
The Goulue entering
the Moulin-Rouge

57
Toulouse-Lautrec.
Jane Avril.
Affiche.
1899.
Poster.

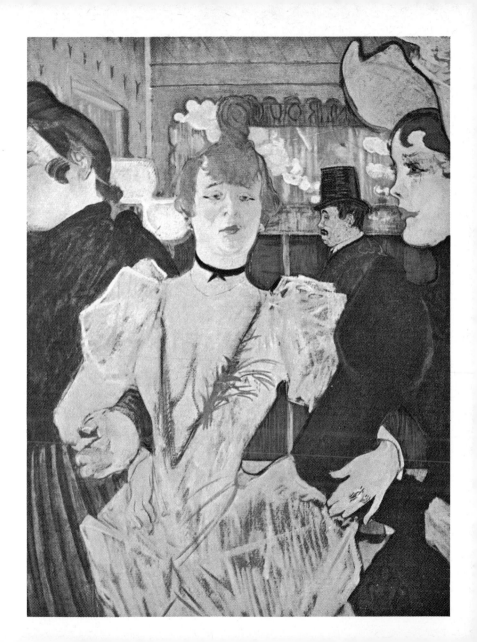

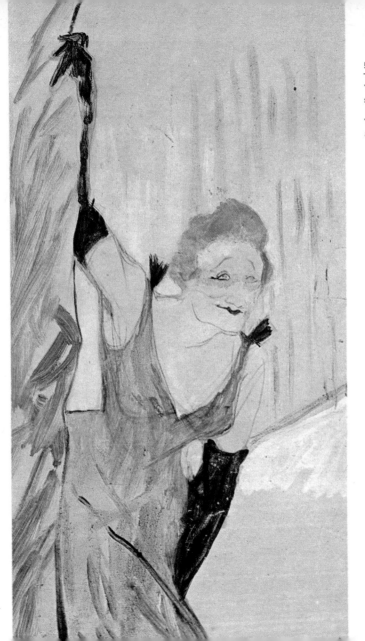

59
Toulouse-Lautrec.
Yvette Guilbert
saluant le public.
1894.
Yvette Guilbert taking
a Curtain Call.

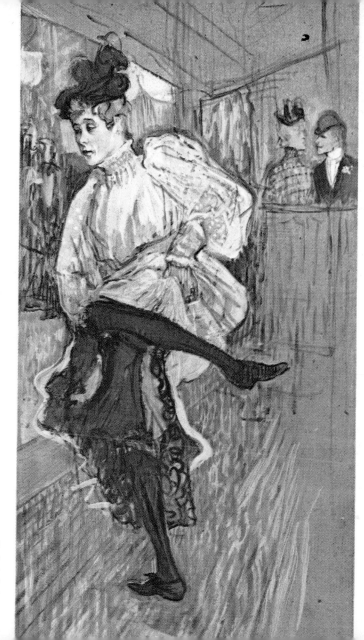

60
Toulouse-Lautrec.
Jane Avril dansant.
c. 1892.
Jane Avril dancing.

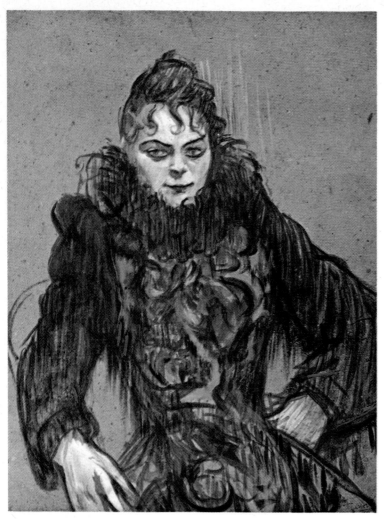

61 Toulouse-Lautrec. La Femme au boa noir. 1892. Woman with a Black Boa.

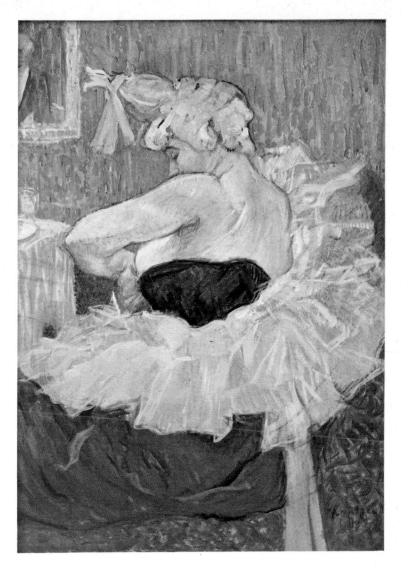

62
Toulouse-Lautrec.
La Clownesse Cha-U-Kao.
1895.

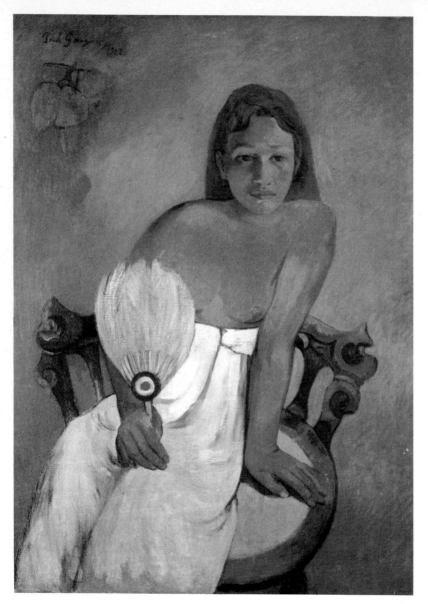

63
Gauguin.
Jeune Fille
à l'éventail.
1902.
Girl with a Fan.

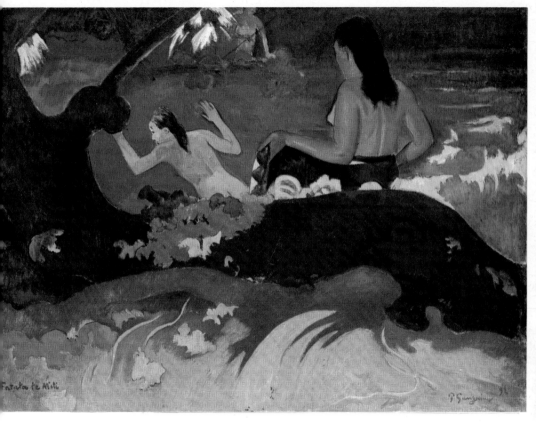

64 Gauguin. Fatata te miti. 1892.

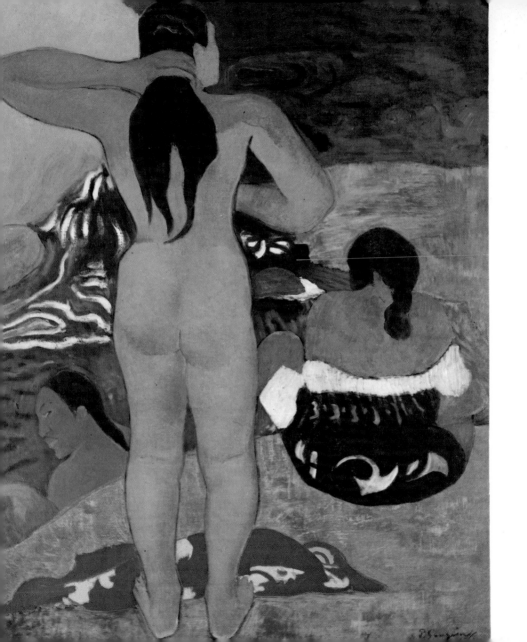

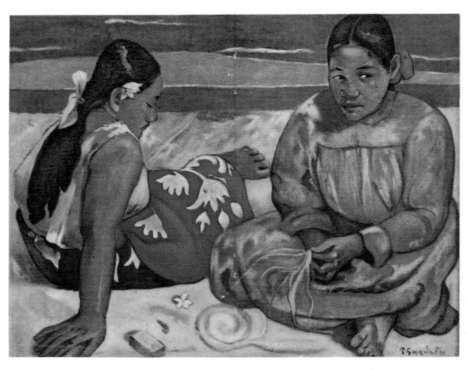

66 Gauguin. Femmes de Tahiti. 1891. Tahitian Women.

65 Gauguin. Tahitiennes sur la plage. 1891-1892. Tahitian Women on the Beach.

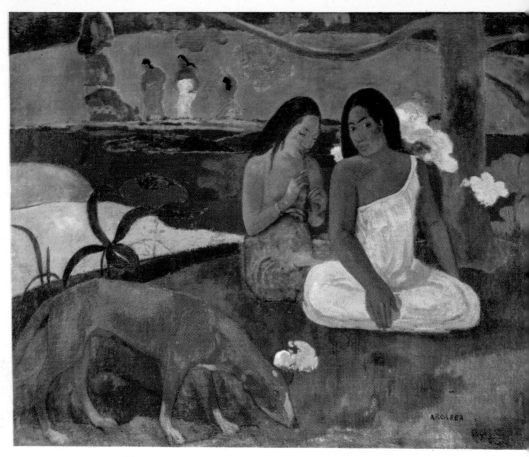

67 Gauguin. Arearea. 1892.

68 Gauguin. ... Et l'or de leur corps. 1901. ... And the Gold of their Bodies.

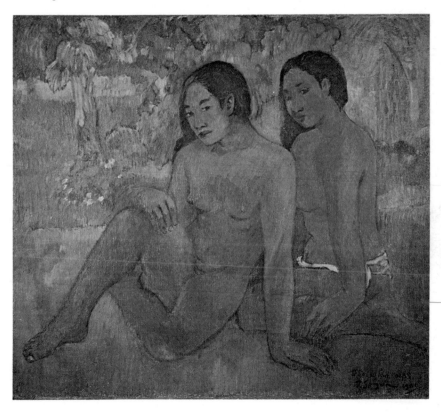

69 Gauguin. Cavaliers sur la plage. 1902. Riders on the Beach.

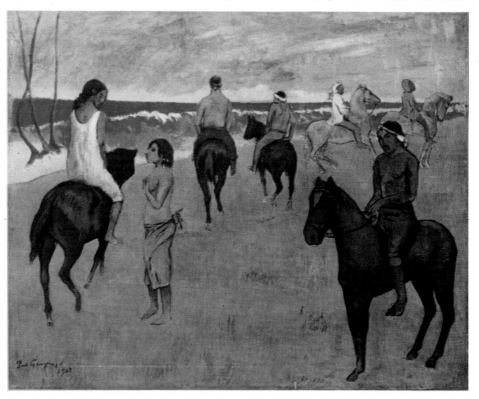

70 Cézanne. Le Vase Bleu. 1885-1887. The Blue Vase. →

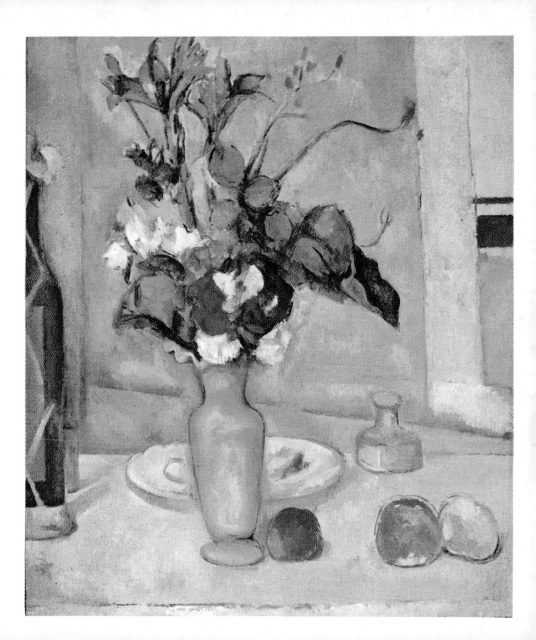

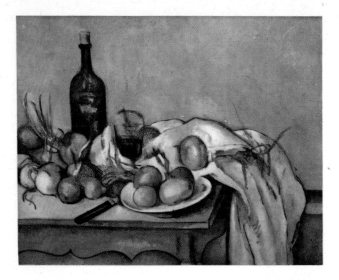

71
Cézanne.
Nature morte aux oignons.
c. 1895-1900.
Still-Life with Onions.

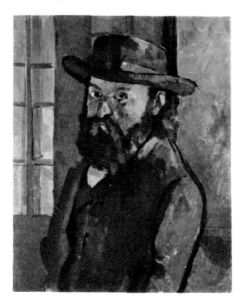

72
Cézanne.
Autoportraít.
1880.
Self-Portrait.

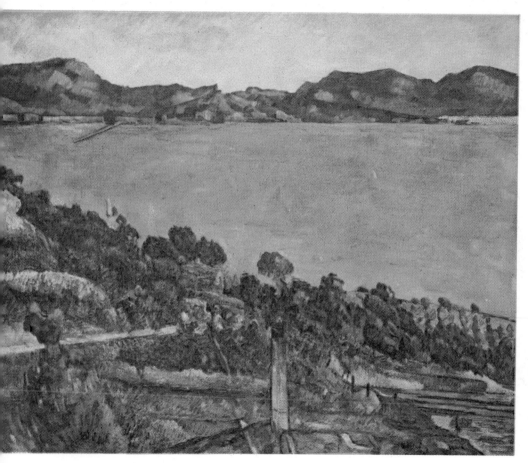

73 Cézanne. L'Estaque. c. 1882-1885.

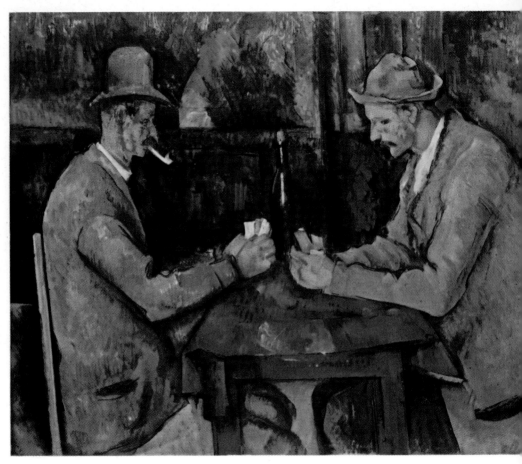

74 Cézanne. Les Joueurs de cartes. c. 1885-1890. The Card-Players.

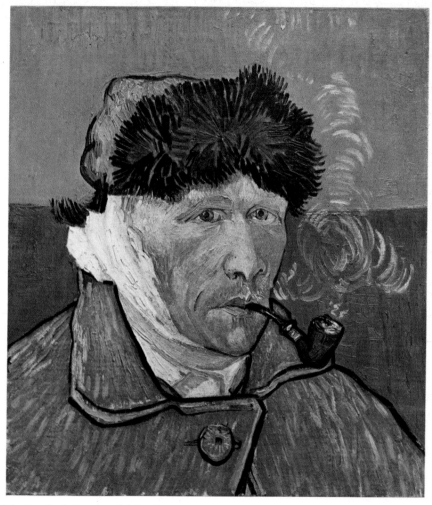

75 Van Gogh. Autoportrait à l'oreille coupée. 1889. Self-portrait with a bandaged Ear.

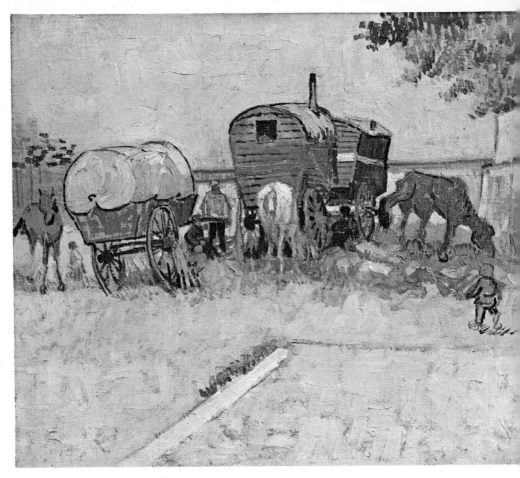

76 Van Gogh. Les Roulottes. 1888. The Caravan.

77
Van Gogh.
La Route.
1890.
The Road.

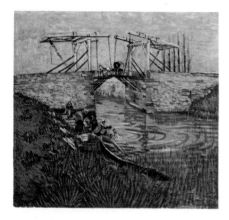

78
Van Gogh.
Le Pont de l'Anglois.
1888.

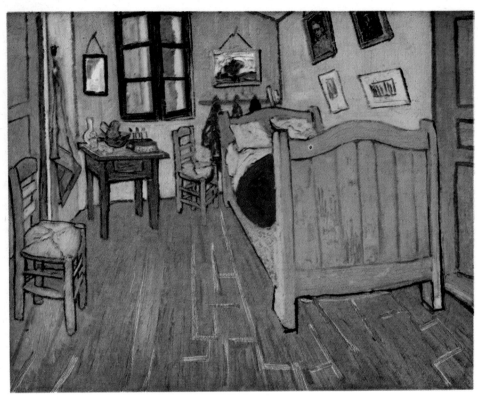

79 Van Gogh. La Chambre de Van Gogh à Arles. 1889. Van Gogh's Bedroom at Arles.

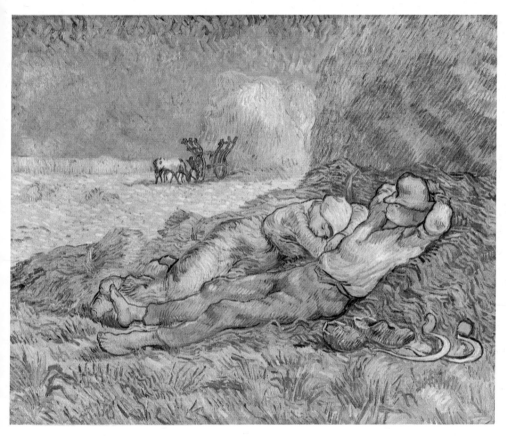

80 Van Gogh. La Méridienne, d'après Millet. 1889-1890. The Siesta, after Millet.

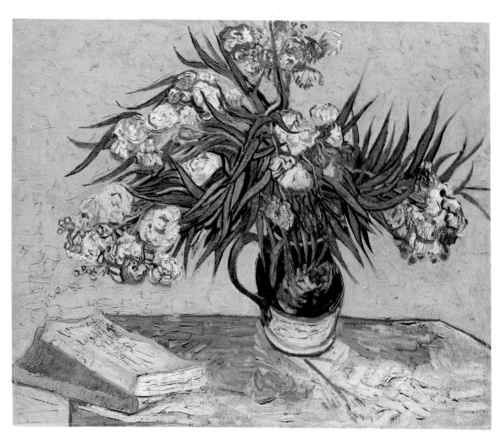

81 Van Gogh. Lauriers-roses. 1888. Oleanders.

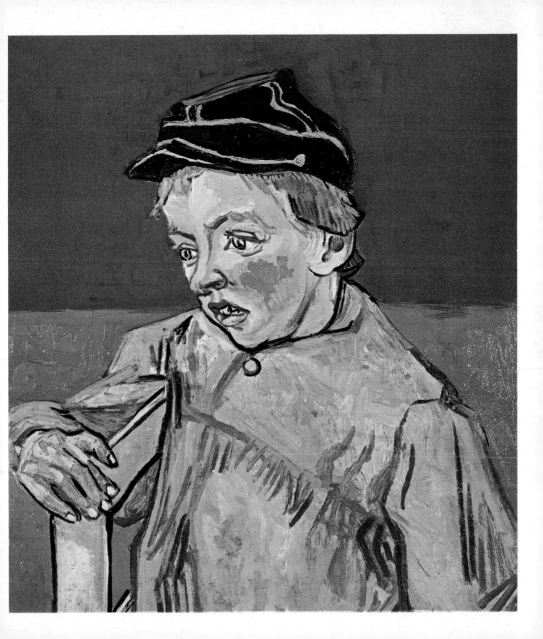

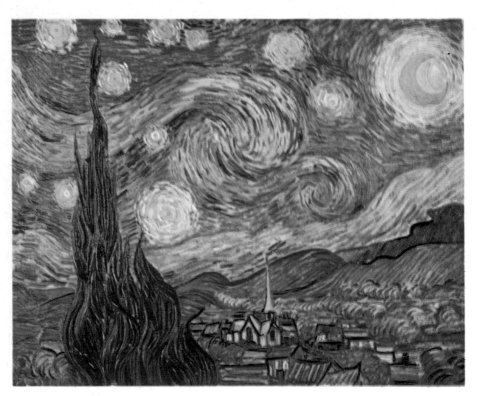

83 Van Gogh. Nuit étoilée. 1889. Starry Night.

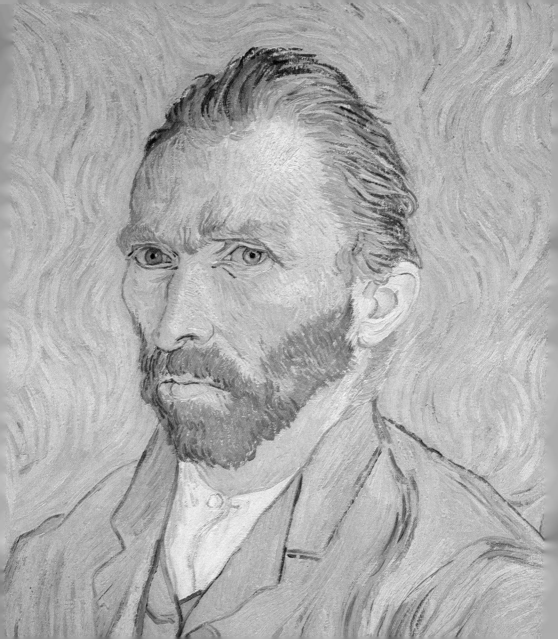

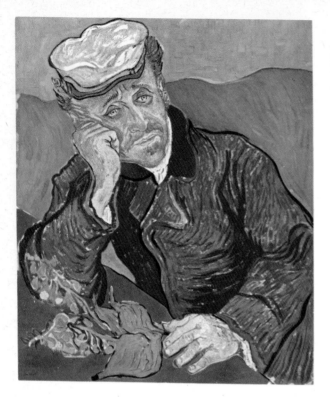

85
Van Gogh.
Le Docteur Paul Gachet.
1890.
Portrait of Doctor Gachet.

87
Van Gogh.
L'Eglise d'Auvers-sur-Oise.
1890.
The Church at Auvers-sur-Oise.

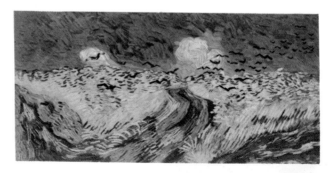

86
Van Gogh.
Champ de blé aux corbeaux.
1890.
Wheat Field with Crows.

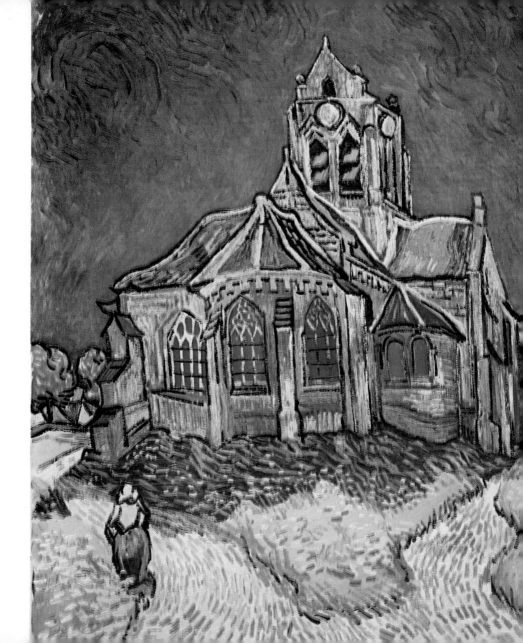

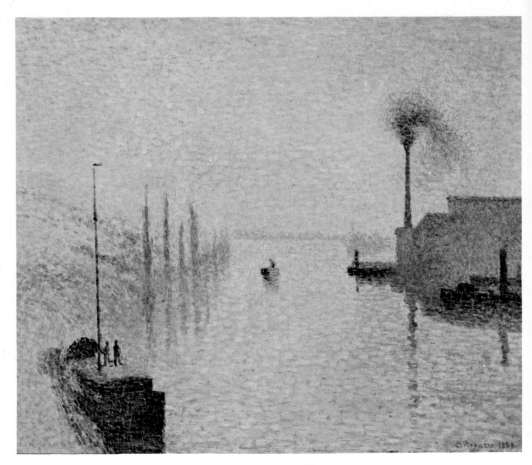

88 Pissarro. L'Ile Lacroix, Rouen. Effet de brouillard. 1888. Fog Effect.

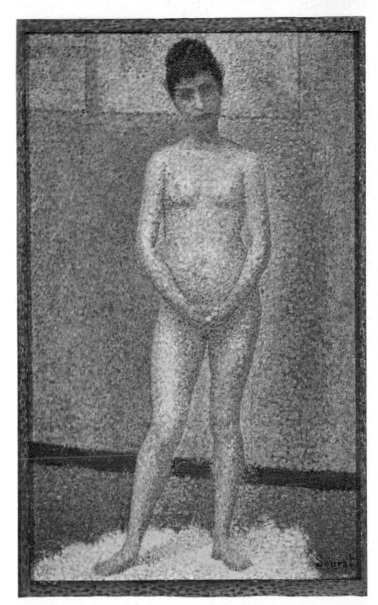

89
Seurat.
Poseuse de face.
1887.
Standing Model.

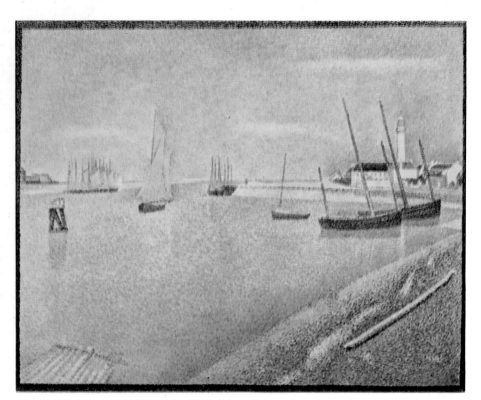

90 Seurat. Le Chenal de Gravelines, direction de la mer. 1890.
 The Gravelines Canal looking towards the Sea.

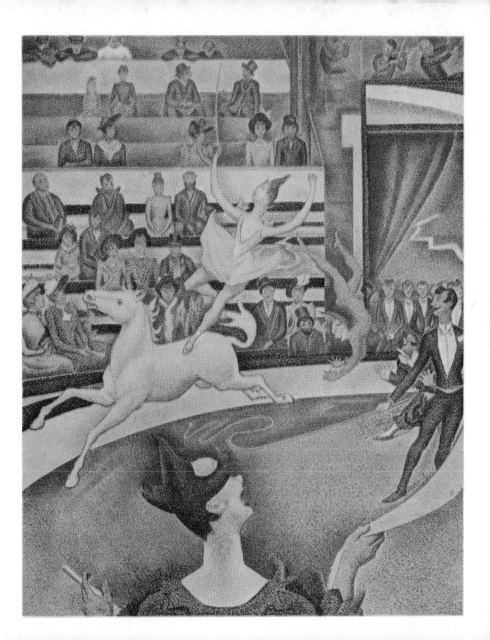